# THE ART
# OF PORTRAITS
# AND THE NUDE

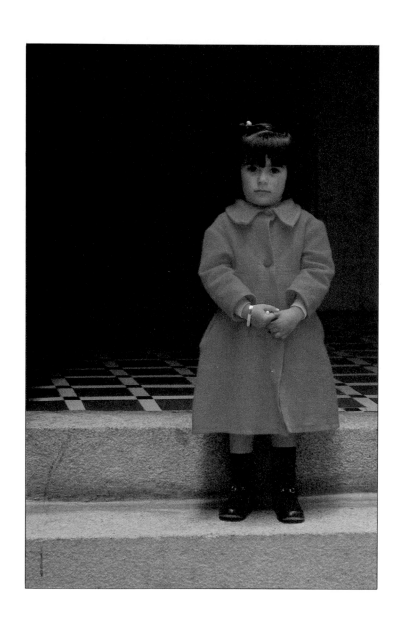

# THE ART
# OF PORTRAITS
# AND THE NUDE

Published by Time-Life Books in association with Kodak

# THE ART OF PORTRAITS AND THE NUDE

Created and designed by Mitchell Beazley International
in association with Kodak and TIME-LIFE BOOKS

**Editor-in-Chief**
Jack Tresidder

**Series Editor**
John Roberts

**Art Editor**
Mel Petersen

**Editors**
Ian Chilvers
Louise Earwaker
Richard Platt

**Designers**
Michelle Stamp
Lisa Tai

**Assistant Designer**
Susan Rentoul

**Picture Researchers**
Brigitte Arora
Nicky Hughes
Beverly Tunbridge

**Editorial Assistant**
Margaret Little

**Production**
Peter Phillips
Jean Rigby

**Consulting Photographer**
Donald Honeyman

**Coordinating Editors for Kodak**
Kenneth Lassiter
Kenneth Oberg
Jacalyn Salitan

**Consulting Editor for Time-Life Books**
Thomas Dickey

Published in the United States
and Canada by TIME-LIFE BOOKS

**President**
Reginald K. Brack Jr.

**Editor**
George Constable

The KODAK Library of Creative Photography
© Kodak Limited. All rights reserved

The Art of Portraits and the Nude
© Kodak Limited, Mitchell Beazley Publishers,
Salvat Editores, S.A., 1983

Library of Congress catalog card number 82-629-77
ISBN 0-86706-212-6
LSB 73 20L 05
ISBN 0-86706-214-2 (retail)

# Contents

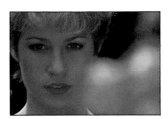
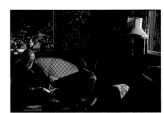

# FACES AND FIGURES

Good portraits are not just pictures of people. They are interpretations of personality: instead of simply recording what the sitters look like, the best portraits reveal what is individual about them, and perhaps what they are feeling. Sometimes, unposed pictures of friends or relatives can have this quality if the natural closeness between photographer and subject combines with technique in just the right way. But a successful portrait of someone you hardly know is more difficult. You must quickly establish a basic understanding of character and a mutual confidence. You must decide what kind of surroundings will strengthen the portrait and what kind of lighting will suit your subject. And then you must find a pose that is telling and which at the same time lets the subject feel at ease.

The same need for consideration and control applies to nude photography. Effective pictures of nudes are never haphazard, whether they are studies of abstract human forms or natural outdoor poses. This book shows how you can extend your skill and creativity in two areas of photography that require special planning and forethought. The examples on the following nine pages succeed as they do because the photographers all had a clear idea of what they were trying to achieve.

*A Japanese actress, posing for a studio portrait, performs a dramatic role for the camera. Perfect, almost shadowless, lighting emphasizes her exquisite beauty. Just as much care has gone into the pose, with one expressive hand included, a gently curving wisp of stray hair and a solitary rolling tear.*

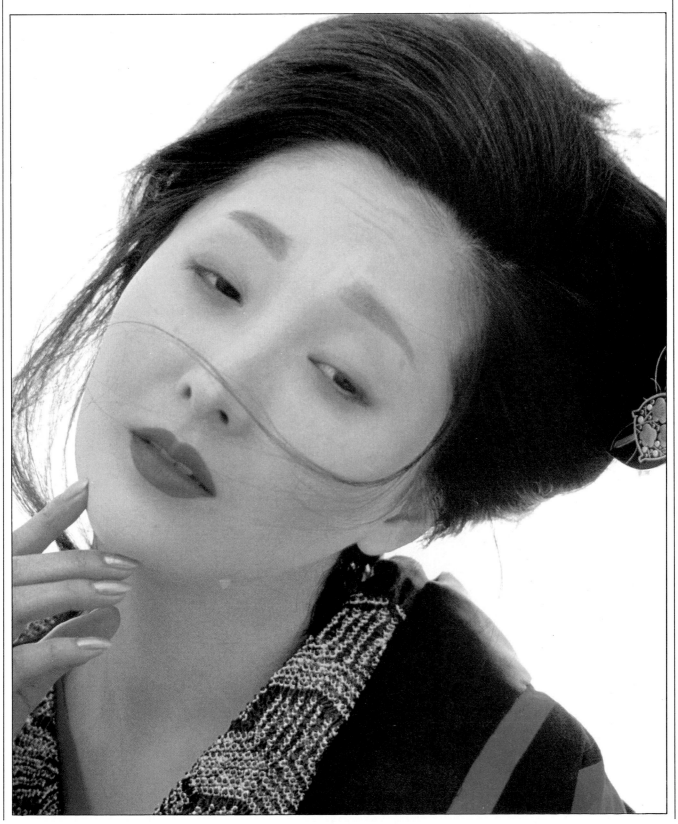

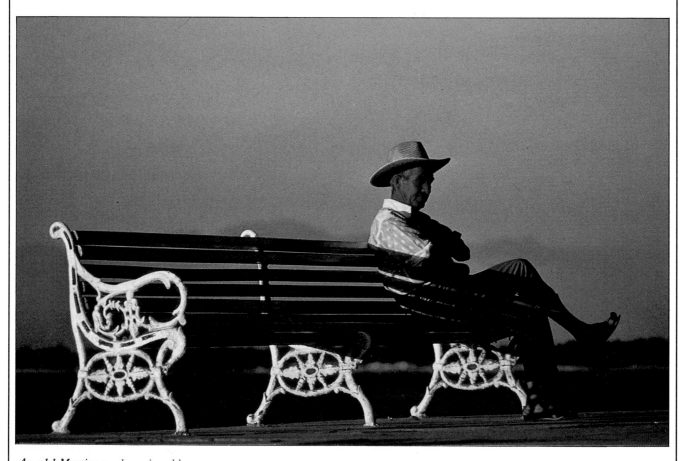

*An old Mexican* relaxes in golden
evening sunlight. The photographer
positioned the subject outdoors in
familiar surroundings to achieve this
natural portrait. Yet the warm light
of the low sun is as effective as any
that a studio set-up could provide.

*A gaudy red room* provides an apt
setting for a painter sitting below one of
her pictures – a pastiche of Velazquez's
celebrated Venus. The photographer
posed her to echo the picture, and used
a single, large studio flash unit.

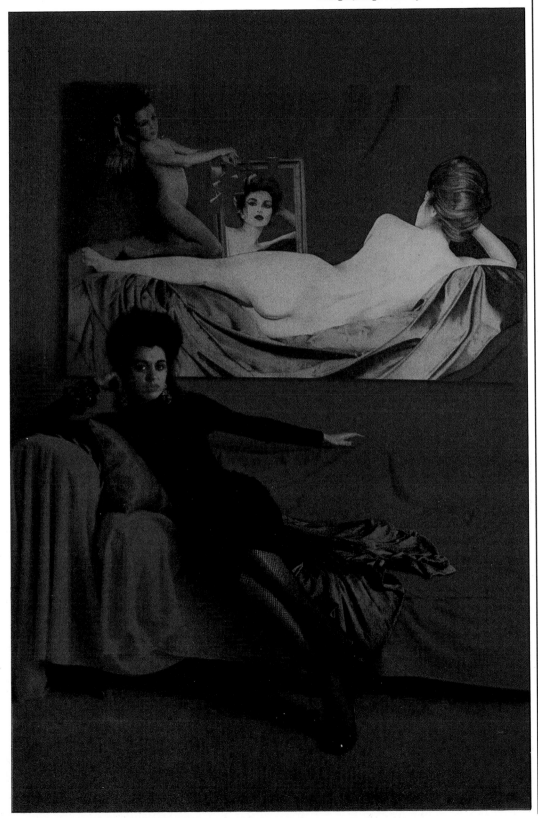

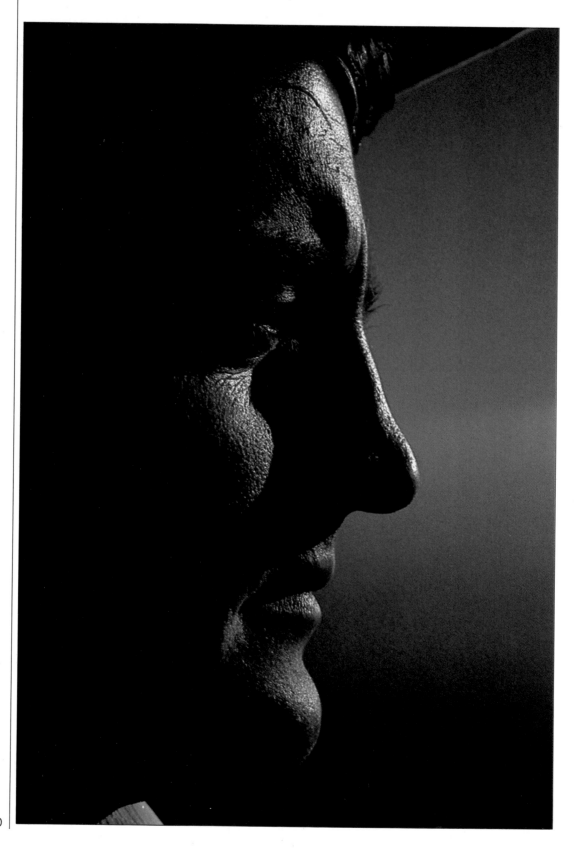

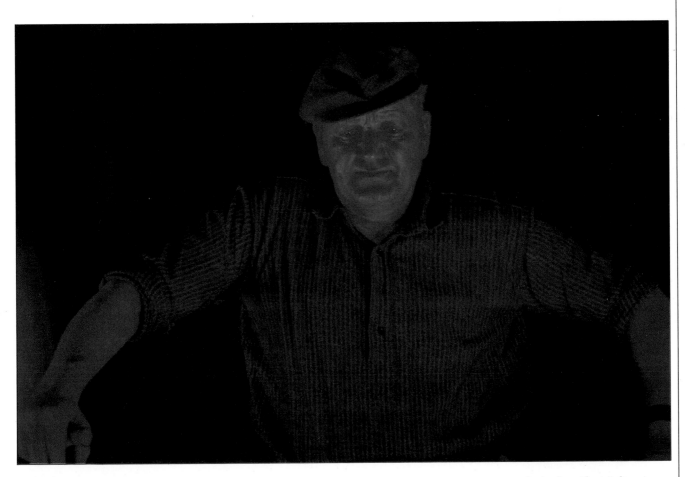

*A rugged profile* (left),
obliquely lit and in close-up,
displays a classic simplicity.
Deliberate underexposure
has increased the dramatic,
high-contrast effect.

*A steelworker* (above)
stands in the glow of the
furnace he tends. By using
this fiery, unnatural light,
the photographer shows the
hardship of the job and the
stolid toughness of the man.

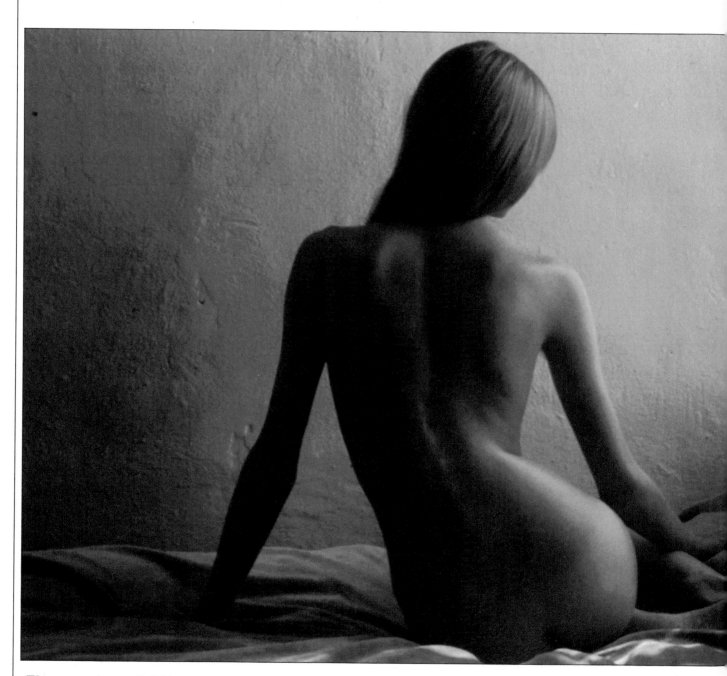

*The romantic mood of this simple nude comes from the use of soft light from a large window, a relaxed pose and an unpretentious setting. The picture's easy naturalness belies its careful planning.*

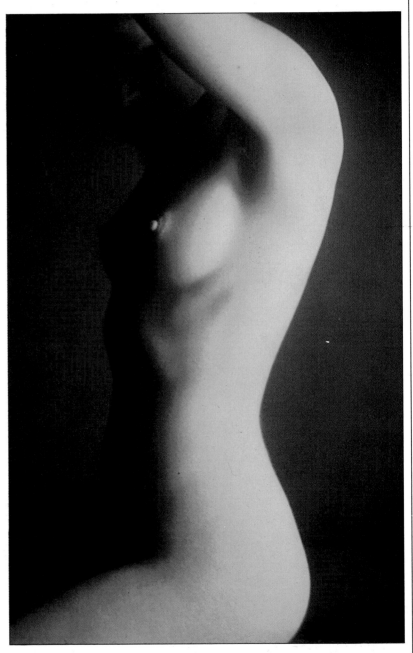

*These full forms* and
*classic lines appear almost*
*as a sculpture in light. The*
*photographer used a strong*
*studio photolamp, diffused by*
*a plastic screen and angled*
*to stress the curved outline.*

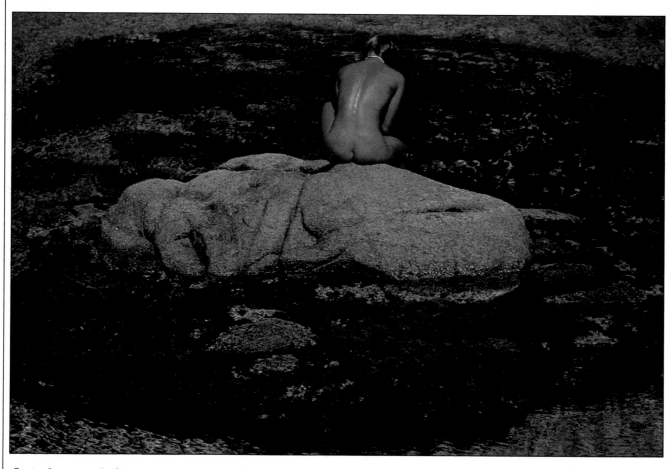

**Seated on a rock** *above a pool of clear water, a girl becomes part of her setting. The photographer framed the scene to exclude the sky and concentrate on the contrast between her smooth body and the roughness of the rock.*

**An athletic black body** *(right) lies stretched out in a surreal landscape – in fact Utah's salt flats at sunset. Deliberate underexposure has increased the harsh contrast in a nude of expressive and elemental power.*

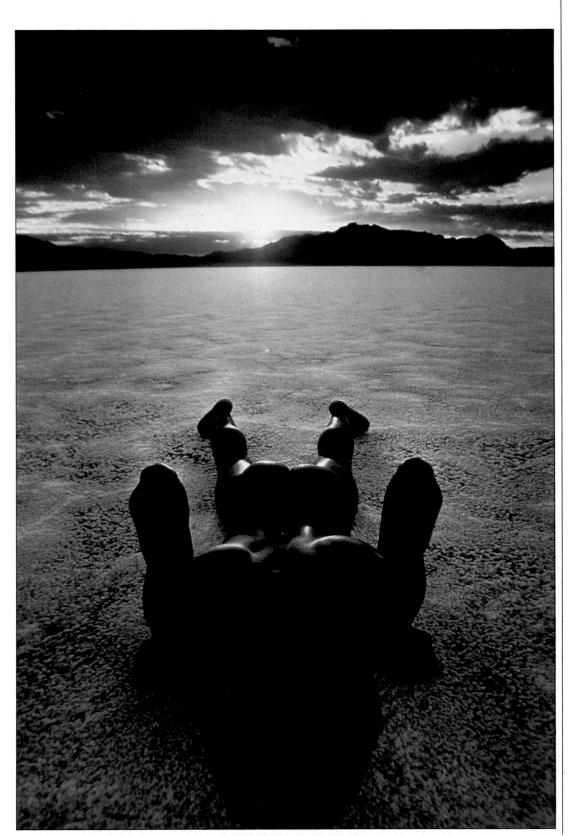

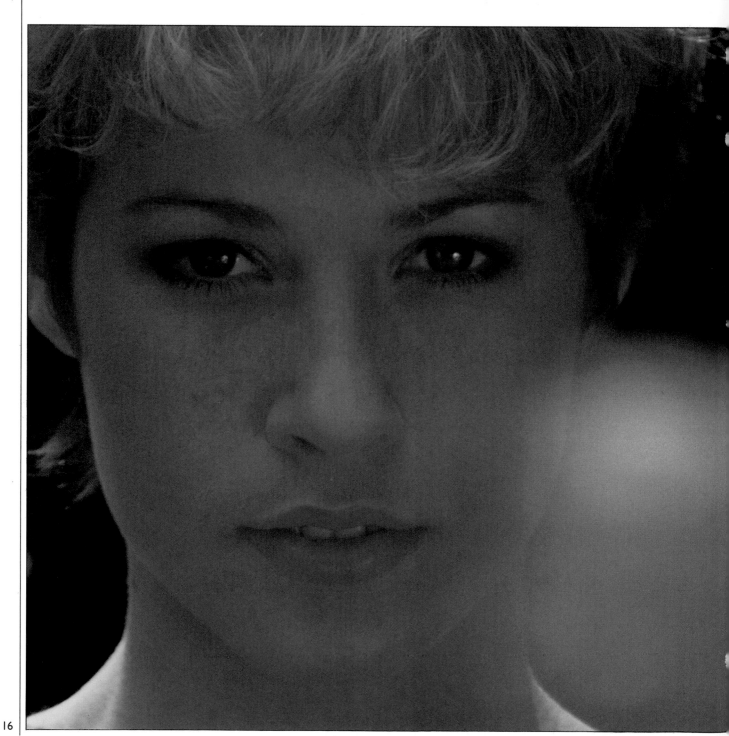

# BUILDING A PORTRAIT

Portrait photography relies on a process of cooperation between photographer and subject. If someone consents to pose for a portrait, try to establish from the outset the mutual understanding that you are working together to achieve a good result. Most people secretly like the idea of a competent photographer taking pictures of them, and you can build on their underlying willingness to help. But to achieve a simple and natural likeness you will have to overcome initial difficulties, because few people can pose formally for the camera without some tension.

Getting people to relax in front of the camera is largely a matter of communication. Try to bolster your subject's self-confidence. Keep a conversation going and be free with compliments. And make positive suggestions instead of criticisms. For example, if your sitter is frowning, take a few pictures and then encourage a change of pose. Once a subject gets involved and feels things are going well, the frown will disappear naturally.

To inspire confidence in your own ability, plan ahead so that you do not appear undecided about lighting or about backgrounds during the session. Have your equipment set up as you intend to use it. In particular, test any special lighting before the subject arrives. By clearly establishing that you know what you are doing, you will help the subject to feel comfortable and relax.

*This charming portrait shows a candid, untroubled gaze beyond the soft pink of two out-of-focus flowers. The photographer warmed the whole picture by using a gold foil reflector to direct some of the sunlight behind the girl back toward her close-framed face.*

# The outdoor portrait

Outdoor portraits have an appeal that is hard to match in a studio, particularly when you can use spontaneous incidents, as in the picture below, where a pigeon provided a natural prop. But you need to choose the right time of day. Early or late in the day, when the light falls obliquely on the subject, is a better time than at midday because the light is less harsh. If possible, plan your session for between one and three hours after sunrise or before sunset, although any time when the sun is below an angle of 45 degrees to the horizon will do. Next, decide how to place the subject in relation to the sun. Be prepared to move around to achieve the best balance of lighting and to include in the view-finder the least distracting background you can find. The diagrams on this page show some of the most effective positions.

The face, of course is the most important part of a portrait. Make sure that you base your exposure on this, not on the background. To expose the face correctly, close right in and see what combination of aperture and shutter speed is indicated before moving back to your chosen camera position. Hand-held meters are particularly useful for portraits. With some, you can take incident light readings by holding the meter just in front of the subject's face and pointing it back toward the camera. Measuring the light falling onto the subject by this method helps to ensure accurate recording of skin tones and color, whatever the brightness of the background or the tones of the subject's clothes. You may find that the light is insufficient for a picture at an adequately fast shutter speed, and that you need to move the subject near a reflective surface or provide a simple reflector, as shown in several of the diagrams here.

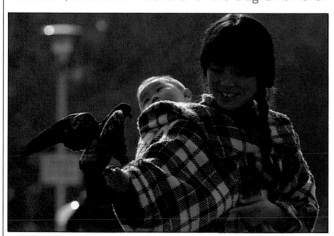

*A young mother feeding a pigeon shows how spontaneous outdoor portraits can look, even though this one was posed.*

## Controlling natural light

For portraits, you should take an active approach to sunlight, not just use it as you find it. Some of the examples below suggest advantageous times of day or how to move your subject into the best light. Others show how to modify the light falling onto the subject with reflectors of white cardboard or crumpled foil.

1 – With the sun diffused by haze or light clouds, you have near-ideal conditions for a soft and flattering portrait.

2 – With low, diffused sun, position your subject so that sidelighting creates strong modeling on the face.

3 – With harsh sunlight, place your subject in the shade, where the light will be more even and the shadows softer.

4 – In the sun, place the subject near a large reflective surface to direct light back into the shadows.

5 – With strong, low sidelight, use a special curved reflector opposite the light to fill in areas of unwanted shadow.

6 – With the sun behind the subject, use a reflector to provide the main source of light falling onto the face.

**Falling snow** (right) is captured with a slow shutter speed of 1/30. In the example here the snow acted as a giant reflector, brightening the light even though the picture was taken late in the afternoon.

**On the beach** (right), harsh sunlight and reflected glare give an unpromising light. By turning the subject away from the sun and using a small hand mirror to reflect light back onto the girl's face, the photographer found an effective solution.

**Bleak conditions** (below) provided good shadowless light for a simple and direct portrait of an outdoor man. A wide aperture blurred out the background.

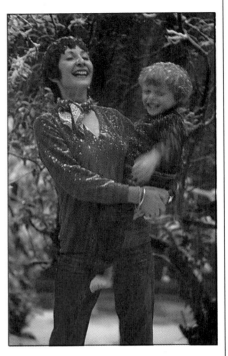

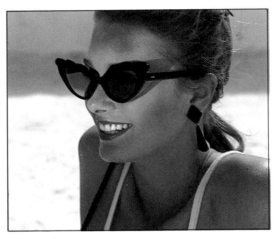

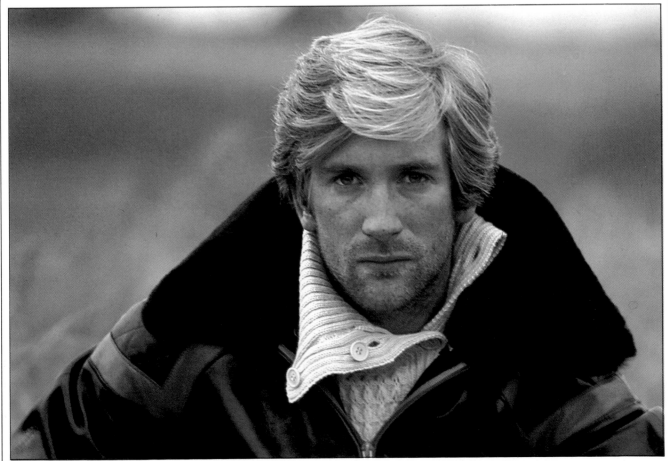

# Natural light indoors

As a light source for portraiture, windows give a photographer a double advantage. Light from a window avoids any need for the studio apparatus that can make sitters anxious, and at the same time has a soft, natural quality that is very flattering. Using this simple light source, you can light a subject in countless different ways. The pictures below, with accompanying diagrams, show four main techniques, but there are many more. In each of the two large pictures at right, a window provided strong directional lighting. With the camera to one side of a window and the subject to the other side turned slightly toward the light, you can achieve excellent three-quarter portraits of this kind.

The crucial thing to remember about window lighting is that although the shadows are soft-edged, they can become deep and inky on the side of the head away from the light. In small or pale-colored rooms, the resulting contrast between light and dark may not be extreme because of light reflected off walls and ceiling onto the subject. But in a large room, or one with dark-colored carpets and furnishings, you may have to use a reflector to put some light back into the shadows. You can improvise a reflector from almost anything pale in color. Sheets of polystyrene are excellent, but even a book or sheet of newspaper will do. Shadows become softer as you move the reflector closer to the subject.

When the sun shines directly in through a window, the contrast increases dramatically, and you may need to soften the shadows by diffusing the light itself. You can do this by pinning a white bed sheet or a couple of thicknesses of artist's tracing paper across the window frame.

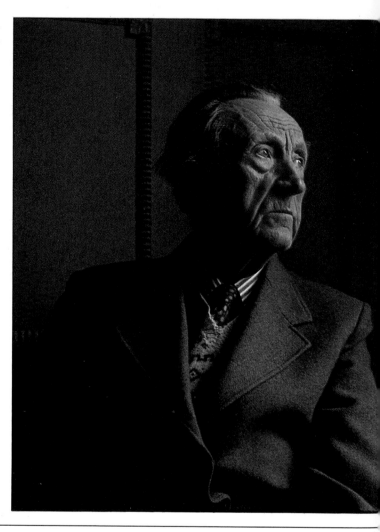

## 1 – Silhouette
The pictures with matching diagrams here show some of the ways you can use the light from a single window. With the camera facing the window and exposure based on the highlight, the subject is silhouetted (ISO 64: 1/125 at f/8).

## 2 – Backlighting
The arrangement was similar for this picture except that the photographer used a reflector to put light into the shadows. Exposure for the face bleached out the window highlight (ISO 64: 1/60 at f/4).

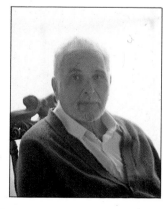
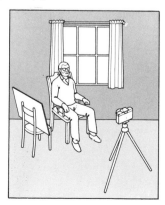

**Looking back** *at a window, the poet Sacheverell Sitwell presents a strong character study. The soft, oblique light shows more form than would a frontal light.*

**Facing the camera,** *this young woman sits close to a window so that the light flows around her features, giving even tones. Tracing paper diffused the light.*

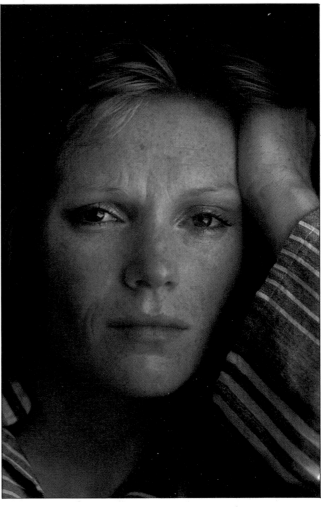

### 3 – Rimlighting
Moving the subject's chair a little to the left makes a dramatic change. Whereas reflected backlighting was soft and flattering, this arrangement begins to reveal the real texture of the face (ISO 64: 1/60 at f/5.6).

### 4 – Frontal lighting
Moving the camera around to point into the room places the subject in more even, frontal light. The thin curtains were drawn to act as diffusers, softening the light on the subject's face (ISO 64: 1/60 at f/8).

# Lighting faces/1

As a way of lighting faces, special photographic light is far easier to control than natural daylight. Even the simplest of the three types of photographic lamps shown at right gives the photographer considerable flexibility in choosing the direction and intensity of the illumination. Each lamp operates in a slightly different way, but for portrait lighting, similar principles apply to all.

To begin with, place the light source slightly above and to one side of your subject's face. If you do not have a proper support stand, fix the light to a door, a chair-back or a stepladder, using a spring clamp or heavy adhesive tape.

Unless you are aiming for a particularly harsh effect, you should diffuse the beam of a single lamp. You can do this by bouncing the light from a reflective surface, such as a white umbrella, or by passing it through a translucent screen. Tracing paper or muslin stretched on a wooden frame makes an adequate diffuser. Place the screen a few feet in front of the lamp to keep the diffuser clear of the hot surface of the bulb.

To avoid casting dark shadows on parts of the subject's face, place a reflector on the side that is most distant from the lamp. The larger and closer the reflector is to the subject, the softer and paler the shadows will be.

With tungsten lighting, you can measure exposure by using your camera meter in the normal way, but flash exposures are not so simple to judge. The automatic sensor of a portable flash unit will be misled by the brilliant white surface of a diffuser or reflector, so you must set the unit to manual. Work out a standard setting for your lighting arrangement by running bracketed exposure tests in advance, using wider apertures than for normal flash photographs. An accurate alternative to this procedure is to use a special flash exposure meter.

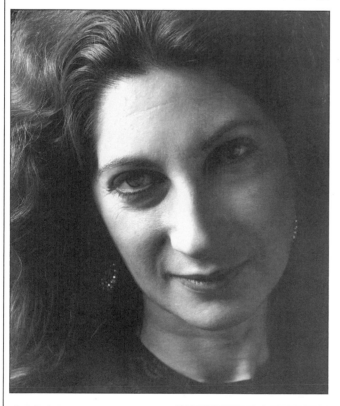

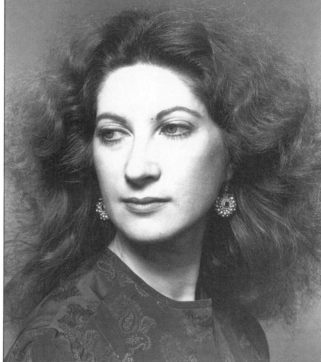

**Sidelighting**
For this moody image, the photographer pointed a flash into an umbrella reflector at the side of the subject. A cardboard reflector placed opposite softened shadows on the other side of the face.

**Normal lighting**
Here the photographer placed the light at a 45° angle to the subject's face to show more of her features, adjusting the reflector slightly. This is a good arrangement for most portrait photography.

## Lighting equipment

A photolamp (near right) with heatproof reflector is the simplest form of special indoor light. This provides far more light than ordinary bulbs, but you need tungsten-balanced slide film to achieve accurate colors. With a portable flash (center) or powerful wall-current flash units (far right), you can use film balanced for daylight.

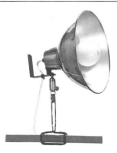

**Tungsten photolamp**
This gives continuous light so that you can see how the illumination falls on the subject. The type shown is fitted with a reflector dish and a clamp for mounting onto convenient bases.

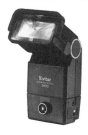

**Portable electronic flash**
The strong light from these battery-powered units should be diffused through a screen or bounced off a reflective surface. To preview the effect of the lighting angle, light the scene first with a desk lamp in the position of the flash.

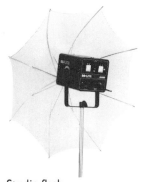

**Studio flash**
This wall-current unit is used with an umbrella reflector. A combined tungsten lamp gives continuous light for gauging the lighting angle.

**Frontal lighting**
Placing the light very close to the camera produces a flatter portrait with greater brilliance. The sitter's eyes reflect the light, and the shadows are small.

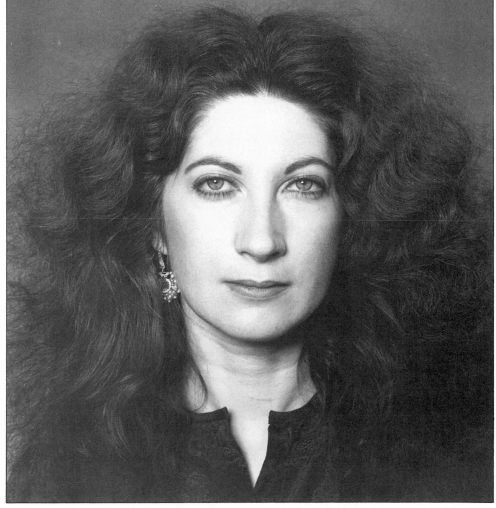

# Lighting faces/2

With two lamps instead of one, the scope of portrait lighting expands dramatically. You can use the second lamp to control more precisely the relative brightness of highlights and shadows, or for effects such as illuminating a background or casting a golden halo of light around a subject's head.

Dark-haired people often appear in portraits with black, featureless hair. To prevent this and put detail back into the hair, place a second light above your subject. Make sure that no light falls on the face by restricting the beam with a snoot – a conical attachment that fits over the light.

Another way to make hair look more interesting is through backlighting. Place a second lamp down low behind the subject, out of sight and aimed toward the camera. This puts a ring of light around a sitter's head. Because hidden backlighting or top-lighting makes no significant contribution to the overall level of light, there is no need to take either into account when setting the exposure controls.

By turning the backlight around, you can illuminate the background. If placed close to the back-drop, the lamp will cast a small pool of light, as in the picture at top right. Moving the background and lamp apart makes the illumination more even. You can also use a second light in place of a reflector to fill in shadows on a face. However, if you do this, make sure the second light is sufficiently far from the face that it does not create a second set of shadows.

Positioning a fill-in light is simple. Switch on the main light first, and direct it as if you were using only one light source. Then switch on the fill-in light, and place this close to the camera – not in the position where you would normally put a reflector. Any subsidiary fill-in light should be dimmer than the main light. If both lamps are of a similar power, place the fill-in light about twice as far from the subject as is the main light.

**Hair light**
A narrowed beam behind and above a portrait sitter puts extra light into the hair, adding brilliance and detail without affecting the main lighting on the face.

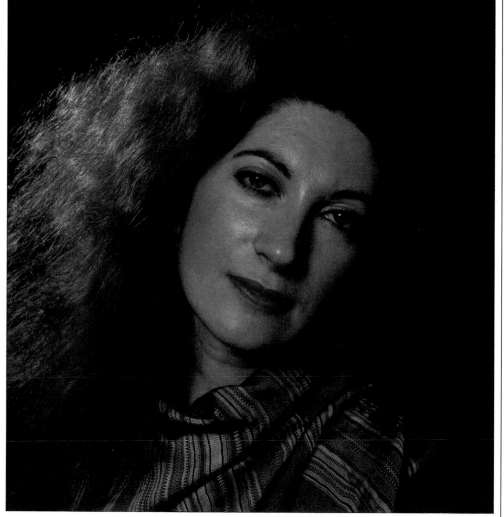

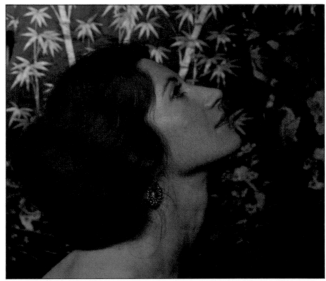

**Background light** (right)
Throwing light on a printed background such as this will bring out its texture and pattern. You can also use a background light to add color to a plain white wall by fitting a piece of colored acetate over the lamp.

**Backlighting** (below)
By placing a light behind the sitter, shining through her hair, the photographer encircled her head with a ring of light. This technique can be useful to distinguish a sitter's dark hair from a background of similar color.

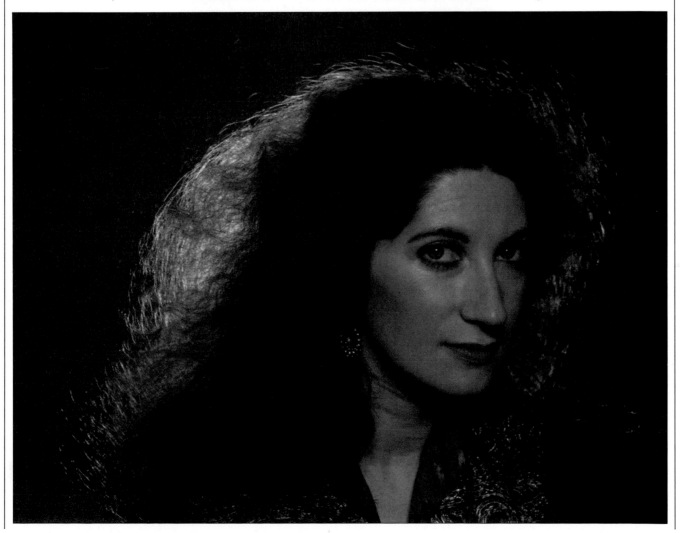

# Hard-edged drama

Theaters use spotlights for dramatic effect, and you can give photographic portraits the same impact by means of strong light directed from a small source. Harsh, concentrated light creates brilliant highlights and sharp-edged shadows that accentuate a subject's bone structure and bring out dominant facial features. The photographs on these pages show how slightly different techniques can create powerful and varied portraits.

Oblique lighting, with a single light source fairly near your viewpoint, can be both dramatic and flattering, as the image below shows. A simple way to set up a small, hard light source is to fit a snoot over a tungsten photolamp. You can then move the light around the room until you achieve just the right play of highlight and shadow on the sitter's face. Alternatively, use a flash unit held a foot or two away from the camera. A useful rule is to place the main light source in front of the face and a little higher than the eyes, which will give good modeling to cheekbones and chin without exaggerating the nose unduly. Then move the light slightly to one side so that the subject is not looking straight at it.

Another approach is to use a broader light source so that some light passes behind the subject to a white backdrop, preventing background shadows. The picture at top right is an example. Using narrow spotlights, you can position the lights slightly behind the subject, as for the portrait of novelist William Burroughs at the bottom of the opposite page.

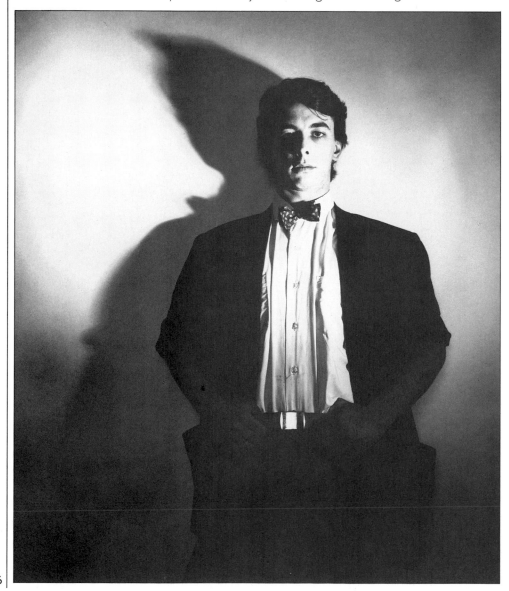

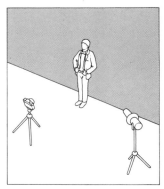

*A beam from one side,* as diagrammed above, stresses this young man's dark good looks. The photographer had moved the tungsten photolamp until the background shadow loomed over the subject.

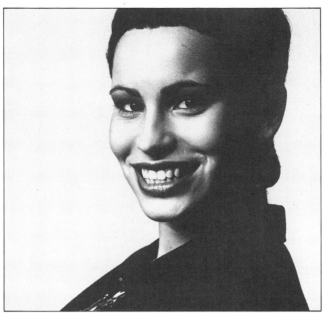

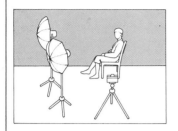

**Two flashes** *reflected from umbrellas (above) produced bold and dramatic contrast in the portrait of the strong-featured woman on the right, lighting her sharply against a shadowless white backdrop.*

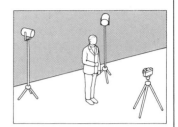

**Two ordinary spotlights** *positioned to the rear, as above, lit the compelling, almost sinister portrait below. Light from each side narrows the face and makes the stare more penetrating.*

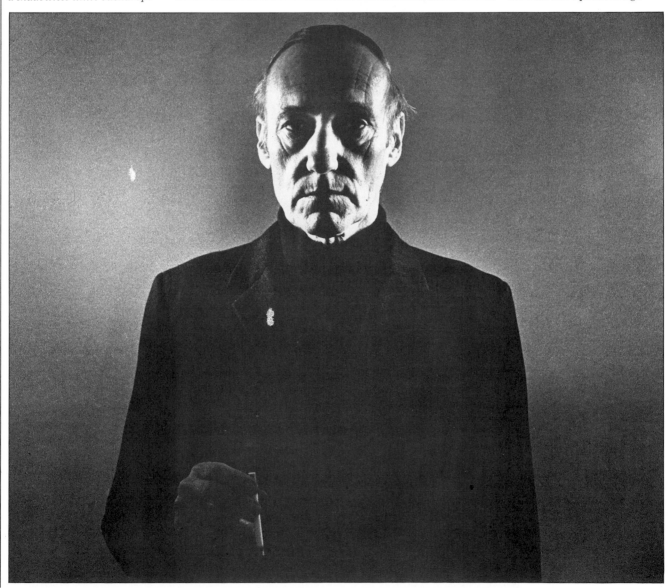

# Soft-focus flattery

Modern lenses give such sharp, clear images that sometimes they may show more searching detail than you want in a portrait. Diffusing the light source, either with a shield such as tracing paper or by finding a naturally diffused source such as the frosted window in the picture of a child below, provides a general solution. But more specific effects are possible if you place a diffuser over the camera lens. Intercepting the light in this way breaks up the image so that light spreads slightly into the dark lines of a face or outward from highlights in the hair and eyes.

Depending on the type of diffuser, you can obtain a very subtle overall softness, as in the picture at the bottom of this page, or a pronounced veiling of the image, creating the kind of romantic effect seen in the portrait on the opposite page. The illustrations at left below, show only three of the many types of diffusion filters available – together with two ways of making your own diffuser. Smearing Vaseline on a plain glass or colorless ultraviolet filter is one of the simplest methods of all, but you should smear lightly and leave part of the glass clear to avoid breaking up the image too much. One trick is to smear the Vaseline in just one direction so that light spreads only this way from any highlight. Because Vaseline tends to melt after a few minutes, you will need to work quickly. An alternative is to stretch a piece of cellophane, with a hole cut out of the center, over the lens. With a wide aperture set, the outer part of the lens will soften the image while the hole in the cellophane yields a clear center.

### Diffusing the image

The illustrations below show several techniques and tools for softening an image by placing a filter over the camera lens. There is a wide range of inexpensive filter attachments for different effects. But you can easily improvise your own diffusing method. The simplest technique is to breathe gently on the lens.

1 – A center-spot filter is an attachment with a round hole in the middle, giving an out-of-focus image with a central area of sharpness.

2 – A soft-spot filter gives a clear central image but with a smoky surrounding area.

3 – A diffusion filter has an uneven surface to break up the light. The effect is an overall soft focus that flatters skin tones.

4 – Vaseline smeared lightly around the rim or streaked across part of a skylight filter will produce unusual and varied diffusion effects.

5 – A fine, gauzy material such as muslin or a nylon stocking, stretched taut over the lens and secured with a rubber band, gives the image a textured look.

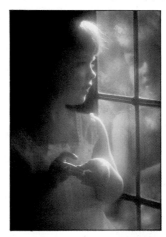

*Diffused sunlight* from frosted windowpanes imparts a translucent gleam to this little girl's flawless skin and models her fine, rounded features. Her reflection heightens the soft-focus effect.

*The musician* shown in sympathetic close-up below was photographed through a diffusion filter. The spreading light has subtly flattered the mature face without losing any sparkle in the features.

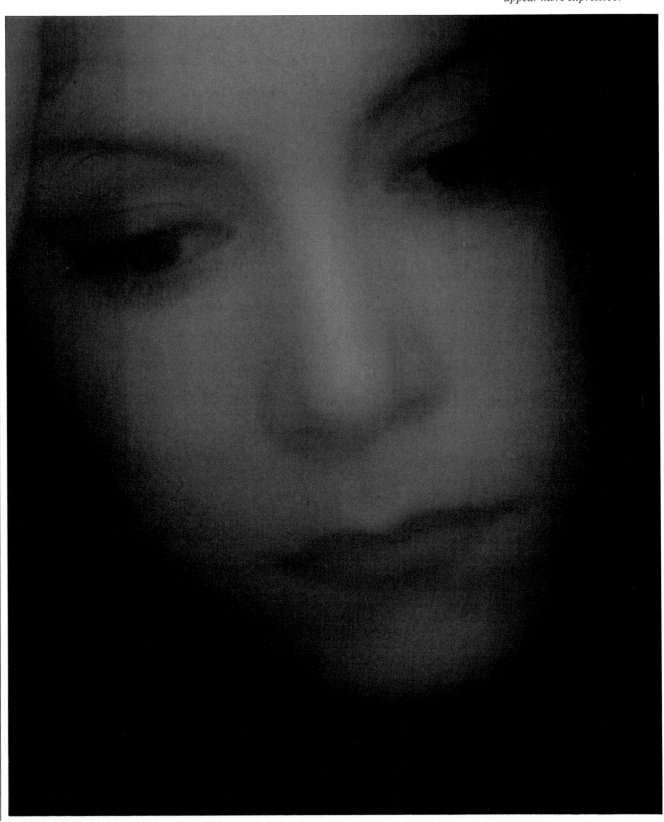

# Head and shoulders

The favorite way of framing a portrait is to include just the head and shoulders of the sitter. This gives full emphasis to the face. Within a head-and-shoulders format, you can close in to fill the frame with just the subject's head and emphasize facial features or else move back for a more general view, perhaps using details of the sitter's clothing to suggest his or her personality. The head-and-shoulders approach suits all kinds of subjects, and requires neither elaborate lighting and equipment nor special background settings.

The main pitfall to avoid is the sort of rigid formality seen in passport photographs. Varying the line of the sitter's neck and shoulders immediately gives a more natural and relaxed appearance and also helps to add interest. The picture at the bottom of the opposite page is a good example.

Viewpoint can have a significant effect on the mood and character of such photographs as the sequence at near right illustrates. The level at which you hold the camera in relation to the subject is important too. Generally, an eye-level viewpoint is the most flattering. Looking down on the sitter tends to conceal the eyes and lengthens the nose. However, a camera position slightly below eye level can effectively suggest authority in a formal study such as the top picture on the opposite page.

*1 – Framing has a dramatic effect on even the most simple and straightforward portrait. Here, closing right in gives full emphasis to the subject's eyes. The photographer used a zoom lens to take all the pictures in the sequence.*

*2 – By pulling the lens back slightly, the photographer included the entire head in the frame, so that the shape of the face is accentuated.*

*3 – The standard framing at left produces a more formal effect. But the sloping line of the body prevents this portrait from seeming staid.*

*4 – The sitter's position in this shot has hardly changed from the one above. But with more of the figure included in the frame to reveal the casual stance, the portrait becomes relaxed and informal.*

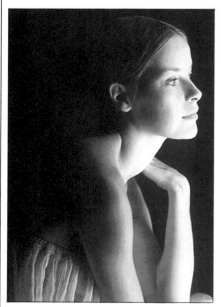

*A graceful, clean-lined profile of a girl in a reflective mood makes a simple yet evocative portrait. The photographer posed his sitter leaning forward on her arms with her face tilted up slightly to obtain highlights on the rounded shoulder and long curving throat.*

*A painting* on the wall behind and a high-backed sofa in front frame the subject of this portrait, and help to lift him away from the distracting pattern of the wallpaper. A low camera angle emphasizes the hands and gives a greater feeling of stature to the figure.

*The languorous smile* below appeared when the girl was encouraged to stretch her arms. The flowing lines of her loose blouse add to the sense of expansive movement that makes this portrait such a delightful one.

# Full-length portraits

Watch two people engrossed in an animated conversation and you will quickly see what an important role the body plays in expressing mood and character. By including the whole body in a picture, you can show the tension or composure in the subject's posture, together with the gestures that add emphasis to a facial expression.

However, a full-length portrait is more complicated than one that shows only the head and shoulders. "What do I do with my hands?" is likely to be your subject's first question. Sometimes, a good way to overcome tension is to seat people on the ground. They will tend to use their hands natur-

ally for balance, as the girl below is doing. Subjects relax more easily when they are sitting down. They also make more compact forms that fit a viewfinder frame better than do the tall thin targets presented by people standing upright. If a seated subject still has difficulty relaxing, suggest the use of a prop such as a book or newspaper.

The most natural full-length portraits are those in which the subjects are absorbed in activity, as is the little girl on the opposite page. Failing this, you can make standing subjects feel less awkward by giving them something to lean or prop an elbow against, as in the series of photographs below opposite.

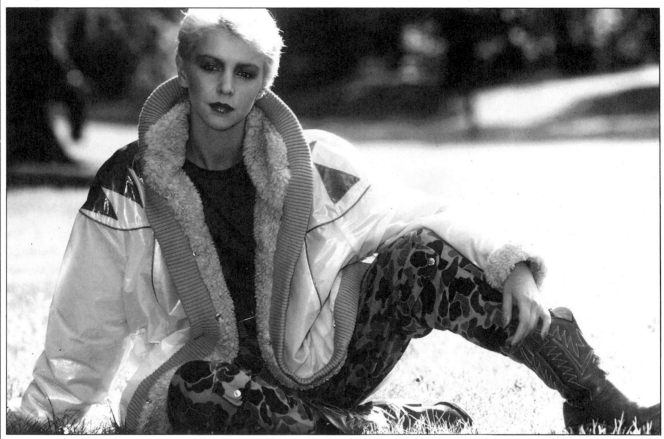

*On the ground, subjects usually take up informal poses and create strong, triangular compositions with their arms and legs.*

*Seated on a chair, most people relax. If they stretch their legs toward the camera, their feet may look too big. To avoid this, turn the chair sideways or move back.*

*A young musician* intently practices scales. Choosing a full-length composition allowed the photographer to capture the awkwardness of this small girl trying to master an instrument almost as big as herself.

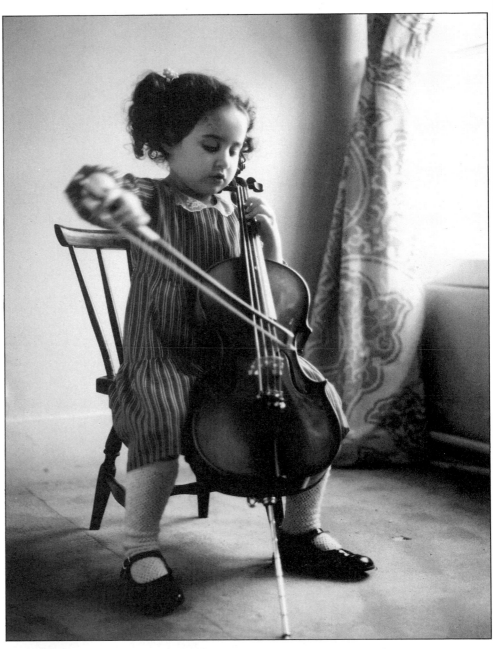

*An easy upright pose* in front of a camera can be difficult for some people to sustain without feeling uncomfortably self-conscious. The model here shows how a shift of weight mainly to one leg makes this kind of pose look more natural and spontaneous. It helps to have something to lean against, such as this bookcase.

  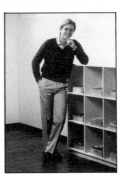 

# Closing in

Tightly cropped portraits convey limited information about a person but have a compensating impact and intimacy. This is particularly true when such portraits are displayed as large prints showing the subject's features life-size.

To take striking close-ups, it is not enough simply to move the camera to within a few inches of a sitter's face. If you do, very likely the picture will look distorted and even bizarre. At short range, a perfectly normal nose may appear grossly enlarged because of its relative closeness to the lens compared with other parts of the face. In a high-angle view, the brow may seem deformed for the same reason. To restore a subject's features to their correct proportions and still fill the viewfinder frame, you must move back a few feet and use a lens that has a longer focal length. The series of pictures at far right on the opposite page shows how backing

away and changing lenses progressively corrects the distortion of the top photograph, which was taken with a wide-angle lens held only 18 inches away.

Lenses with focal lengths between 85mm and 135mm – or zoom lenses – are best for close-ups, allowing you to stand about three to five feet away. But whether you are standing fairly near a subject or farther away with a longer lens, close-ups require extra care because the depth of field is very shallow. Focus on the eyes – or on the nearest eye if the head is turned. Check carefully by using the camera's preview control to see how much of the face is sharp. You can maximize depth of field by taking pictures in bright light and stopping the lens down to a small aperture. However, remember that a sharply focused close-up will expose a face to intense scrutiny, and that you may want to diffuse a strong light to soften the effect.

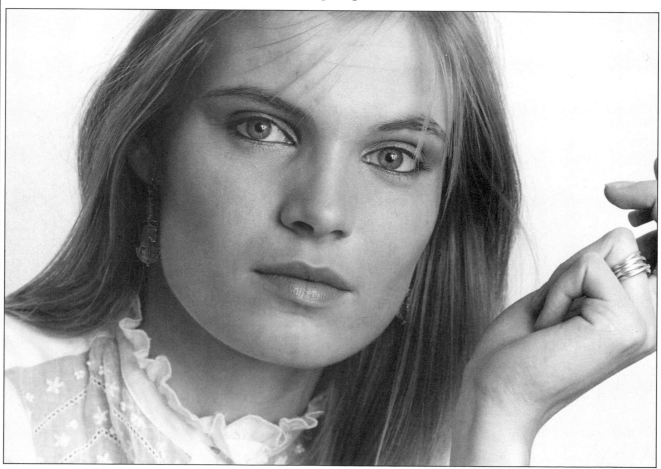

*A penetrating look gains impact from severe framing. By cropping at the hand and forehead, the photographer draws our eyes to the subject's gaze.*

*A child's softly rounded face (right) emerges from a white towel. To stress the wide-eyed look, the photographer closed in with a 135mm telephoto lens.*

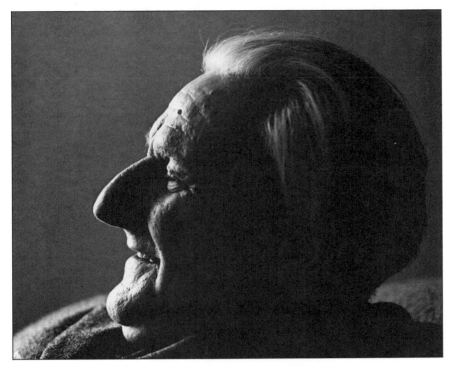

*A profile portrait* reduces the risk of awkward distortion because the most important elements – eyes, nose, mouth and chin – are on nearly the same plane. Here, strong sidelighting gives a stark, high-contrast study of character.

28mm

*1 – A wide-angle lens* fills the frame with a face only at very close range - just over one foot. This makes the subject's nose and the nearer side of the face appear misshapen.

50mm

*2 – A normal lens* from a distance of about two feet produces a more pleasing image, but some distortion is still evident.

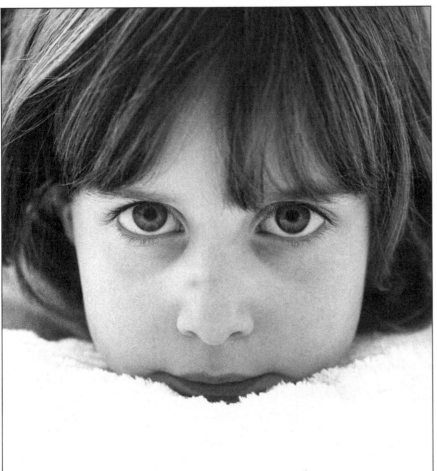

105mm

*3 – A moderate telephoto lens* lets the photographer stand back about four feet. This shows natural proportions and also avoids crowding the subject with the camera.

# Changing the mood

The balance between exposure, lighting and the tones of the subject or background controls the "key" of a portrait – a distinctively photographic quality that you can adjust to convey subtle nuances of mood. Bright, high-key images tend to suggest youth and lightness of spirit, whereas predominantly dark, low-key images with only small highlight areas have a more solemn effect.

Of course, there are intermediate tonal keys – as shown in the sequence below, in which the tone of the background and the quality of the lighting play major roles in determining the final effect. A large, diffused light source bathing the whole subject in even light against a white background will give a very high-key portrait, particularly if the subject is light-haired and fair-skinned. Slight overexposure will add to the effect. Remember that a camera exposure meter reading of an overall bright scene will indicate a reduced exposure to darken the image to a mid-tone. If you do not want this, give at least one extra stop of exposure or set a film speed slower than that of your film.

Progressively more low-key effects can be gained by providing a darker background, or by leaving the background unlit or in shadow. You can also reduce the size of the light source, move it farther away or adjust the angle, so that the shadows are larger and deeper. With a black background and single spotlight shining on one side of the face only, the portrait may have a moody, even sinister, impact.

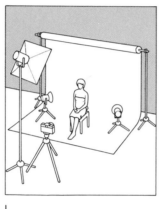

*1–For a high-key result, the photographer used a large tungsten photolamp, diffused by a large sheet of tracing paper, placed above the camera and close to the subject. Two extra lamps lit a white backdrop. One extra stop of exposure over an average reading heightened the pale effect.*

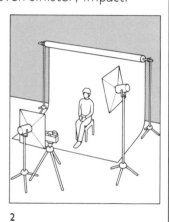

*2–For a moderately high-key effect, the main light was placed slightly lower and moved to the right of the subject. A second light, more highly diffused and near the camera, filled in the shadows and softened the modeling of the face. The background paper was gray.*

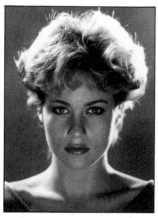
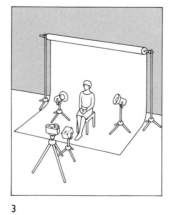

*3–For increased drama, the photographer directed two lights onto the subject from behind, rimlighting neck and hair and leaving the gray background darker. A third light, heavily diffused and placed below the camera, provided direct light on the face, particularly the eyes.*

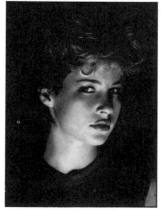
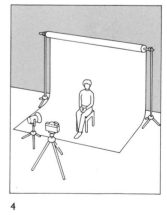

*4–For a full low-key result, the photographer used a single small light to one side and low down. No light fell on the background, which appears entirely dark. Spotlights are best for this kind of high-contrast result, with much of the face left in shadow.*

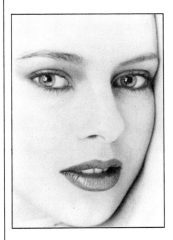

**The close-up portrait** above relies on pose, make-up, lighting and exposure for a soft, high-key effect. The girl lifted her arm beside her face in order to exclude the background, and wore pale cosmetics. The photographer used a large, diffused light and gave two stops more exposure than the camera's meter indicated.

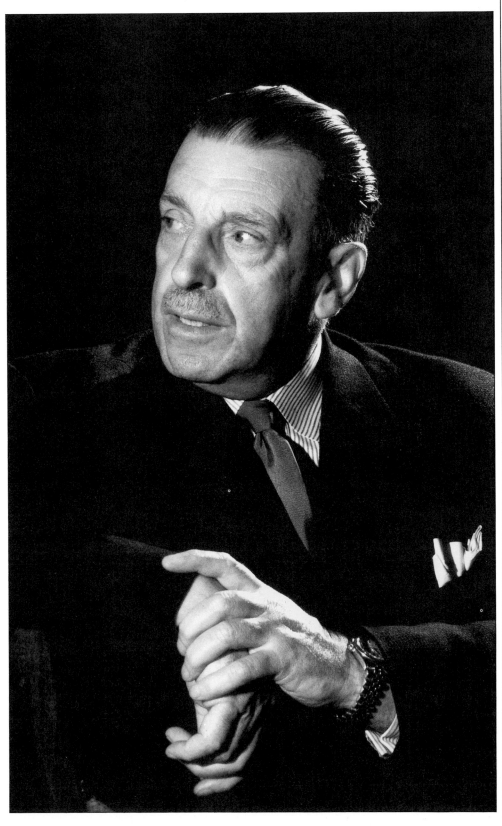

**A powerful personality** (right) is made even more forceful by using a low-key lighting arrangement and slight underexposure. A spotlight to the right of the subject put highlights onto the hands and hair, while a softer lamp to the left lit the pensive face.

37

# Self-portraits

The simplest way to take your own portrait is to photograph your reflection in a mirror. Of course, if you hold the viewfinder to your eye, the camera will appear in the picture and obscure part of your face. The diagram below at left shows how you can avoid this by first lining up the picture and then raising your head above the camera before releasing the shutter. Remember that the focusing distance is actually that from the lens to the mirror and back to your position: it is the reflection, not the mirror, on which you must focus. With a single lens reflex camera, you simply focus on the reflection as it appears in the viewfinder. Alternatively, use a tape measure to find the total distance from you to the mirror and back to the camera, and then set this distance on the focusing scale.

The other main way to take a self-portrait is to use a cable release or the camera's self-timer while posing in front of the lens (as illustrated below middle and right). Set up the camera on a tripod and look through the viewfinder to see where you should stand or sit. Then place something, perhaps a chair, in this position to adjust the framing and focus. To prevent errors in framing, leave space around where your head will be.

When using the self-timer, practice releasing it and taking up your pose a few times before loading film. The click of the shutter gives you an idea of how long you have to prepare yourself. For more exact control over the moment of exposure, you have to use a special long cable release, as shown in the middle diagram below and used for the picture of a woman looking through a wet window on the opposite page. A mirror placed behind the camera is useful for monitoring your expression in an eerie picture such as the one at top right opposite.

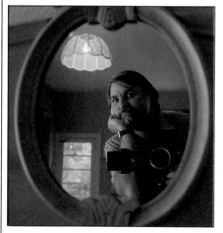
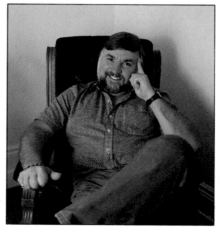

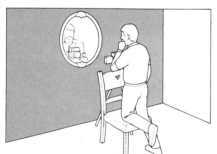
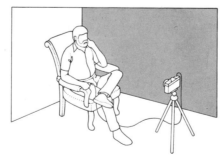

*In a mirror,* you can see exactly how your expression looks. For the picture above, the photographer gauged the correct viewpoint and focus with the camera steadied on a tripod, then lifted his head clear. Alternatively, stand in front of the mirror with the camera at waist level and tilt the lens upward until the camera's reflection appears to point directly toward you.

*A long cable release* permits you to sit in a chair while you take your picture. However, because you must press a plunger at the end of the cable to release the shutter, you may need to disguise the cable in the picture. The photographer above is holding the cable unobtrusively along the arm of the chair on which his hand rests, and the pose seems completely natural.

*A self-timer* leaves your hands free, but the camera can catch you unawares – in the picture at top the photographer's eyes are closed. The white-striped lever next to the lens in the picture above sets the camera's self-timer mechanism. Usually the delay is eight to ten seconds, and you should practice to get the timing right. Self-timers on some cameras may incorporate bleepers or flashing lights.

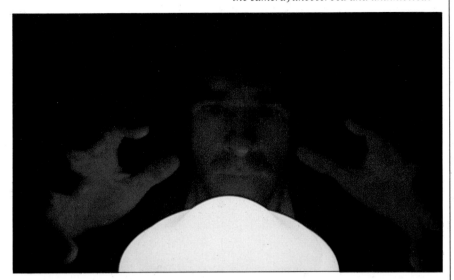

*A glowing lamp* illuminates a man's features from below, giving this unusual self-portrait an eerie, supernatural aura. Outlandish ideas such as this often work better if the photographer is alone with the camera, unobserved and uninhibited.

**Tripod and cable release**
A tripod makes self-portraiture easier – an adjustable head directs the camera where you choose. A long cable release screws into the camera's shutter release knob, and enables you to trip the shutter from a distance after posing yourself.

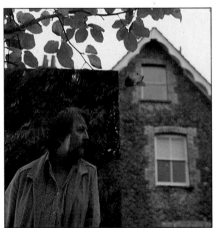

*An outdoor self-portrait* shows not just the photographer, but his home and garden as well. The twisted reflection in the plastic mirror is disquieting – an effect the photographer heightened by averting his face as he took the picture.

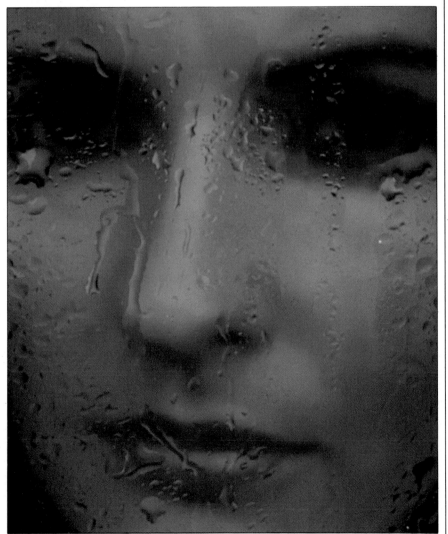

*Through a wet window*, this self-portrait looks like the face of a wax doll. In order to get the composition right, the photographer first framed and focused a single pane in a leaded window, then walked outside with a cable release to pose behind the pane and take the picture.

# Full-face or profile?

A full-face view can communicate with a viewer in a very direct way – perhaps through laughter or through the kind of challenging stare seen in the picture at left below. This approach can suit people with good eyes and regular features. But unless a sitter is confident and assertive, you risk the dullness of a passport photograph.

Profile views sometimes look excessively staged, and subjects may be wary of them because most people are not familiar with their own profiles. However, if you liven up the picture, as at right below, profile portraits can be unconventional and striking. This approach shows beautiful hair to advantage, especially with the head thrown back slightly to show the subject's long and graceful neck. In order to emphasize a profile, place the light ahead of the face and slightly farther back than the subject from the camera.

Three-quarter views, as shown in the picture on the opposite page, are in fact much more common in portraiture. They allow eye-contact with the camera, lost in a profile, and give a more relaxed impression than does a full-face portrait. Usually one side of a face looks better than the other, as models are well aware. If you are in doubt, take pictures from both sides and make a choice later. To achieve a natural pose, have your subject face slightly to one side and then look back toward the camera without any head movement. This contributes a hint of spontaneity, as if you have caught a personal glance. Keeping a conversation going will help subjects to relax, and a joke or smile may encourage similar responses. If not, suggest that the subjects stretch, shake their shoulders or even screw up their eyes. A smile may then appear quite naturally when you tell them to relax again.

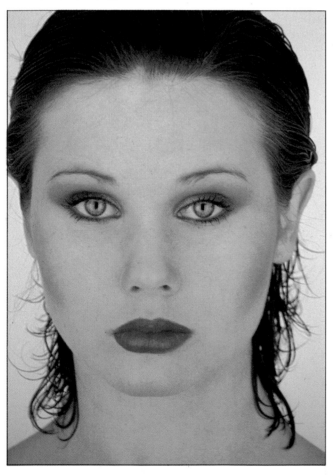

*A gray-eyed beauty fixes the camera with a cool stare. Careful makeup and wet hair simplify her face so that the eyes and mouth stand out.*

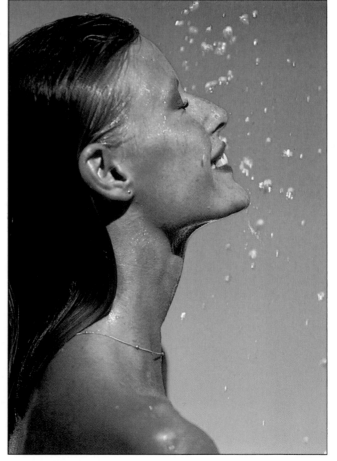

*A splash of water, frozen by an electronic flash, brings this simple profile to life. The girl's tilted head makes her neck seem longer.*

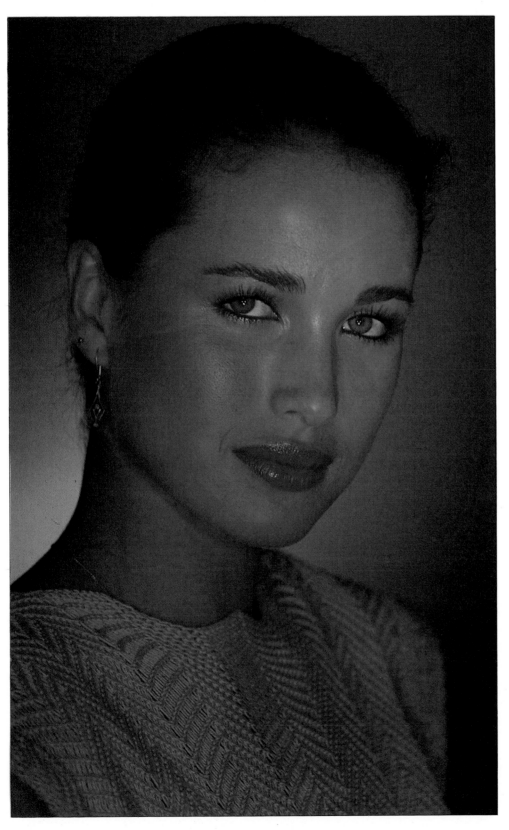

*A warm glance,* backed up by a hint of a smile, gives this classic three-quarter portrait a relaxed and engaging intimacy. The photographer covered the lights with orange acetate for a bronze glow.

# Double portraits

The arrangement of two people within the frame of a picture is best kept simple. The slightly elongated rectangle of the 35mm format suits a horizontal head-and-shoulders treatment, with the pair standing beside each other. But beware of placing two heads side by side on the same level. Unless the pair are looking toward each other so that both are in profile, this may produce a dull result. A more natural solution for a loving couple is shown below, with the woman's head lower than the man's.

Often you can achieve more varied poses and framings if you turn the camera for a vertical picture and arrange the couple on different levels. Try having one sit, and the other stand slightly behind with one hand resting on the chair. If you want to avoid too conventional a picture of a couple, suggest that the woman stands while the man sits.

In lighting two people, the principles are the same as for a single portrait, but there are a few special problems. Outdoors, unless the light is shadowless, you should take care to arrange the couple so that one does not cast shadows on the other. With natural light indoors, make sure that both are equally distant from the window or door supplying the light, otherwise the rapid fall-off of light will create an exposure problem, with the person farther from the window appearing much darker. Photographic lights should be placed squarely to the front of the subjects, or else divided in such a way that each receives equal light.

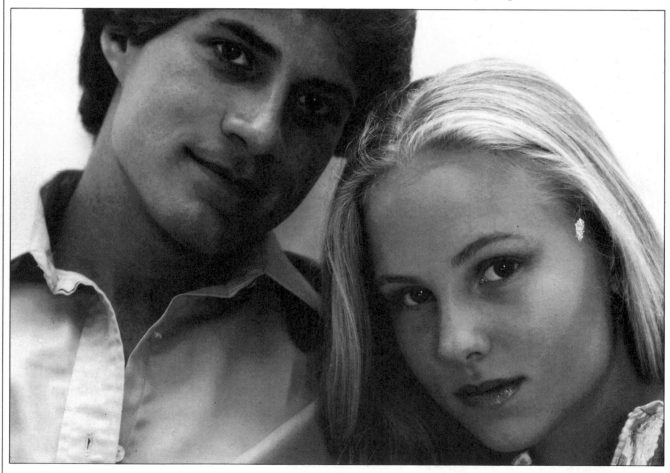

*A young couple* snuggle together and fit perfectly into the shape of the 35mm frame. A diffused studio light high up and aimed toward two large reflectors in front of the couple produced the near-shadowless lighting.

*Two bikers* pose proudly with their Harley-Davidson. Asking them to sit together on the motorbike against the plain background (a large piece of draped matting) encouraged a delightfully relaxed and informal pose.

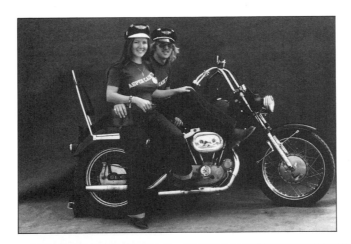

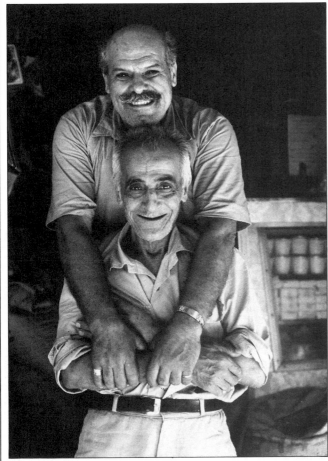

*Close friends* from years of working together in the same store have a chance to express their relationship naturally because the photographer suggested this unusual and striking pose. The rear man is standing on a box.

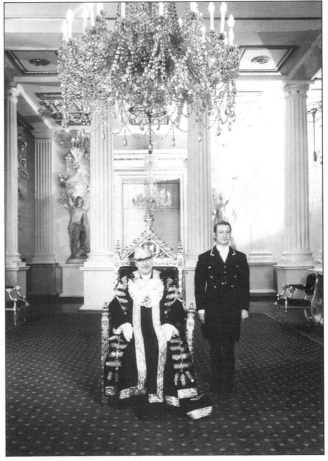

*A formal portrait* of the Lord Mayor of London in regalia includes a liveried servant. Here, the second figure seems little more than a prop, contributing, like the gilded throne, to the sense of grandeur.

# Group portraits

The aim of a group portrait is to show everybody looking alert and attentive and at the same time to convey the sense of a common bond. The secret is first to get the general arrangement of the group right and then to work on the pose and appearance of each individual. Encourage the members of the group to relax by talking to one another, but keep sufficient control to command their undivided attention when you are ready to take the picture.

The photographer built the picture at near right around a common theme by arranging a restaurant's staff around a table laden with food, then positioned each one according to his individual role. Because figures in front can obscure those behind, posing large, informal groups presents a special challenge. One natural solution is to move the group to a flight of steps or a slope, as in the picture below. Failing this, get higher with the camera. Even standing on a chair will give you a better view of each individual.

When you are photographing a group indoors, you may have to set a wide aperture to take maximum advantage of restricted light. Unless you can retain adequate depth of field by using a wide-angle lens, you will need to arrange your subjects at roughly equal distances from the camera so that all come within the narrow zone of focus. And if you are using flash or tungsten photolamps, maintaining an equal distance is also important to avoid uneven lighting. With a group close-up, as on the opposite page, you can bring people together simply by having them turn their shoulders or put an arm around the next person.

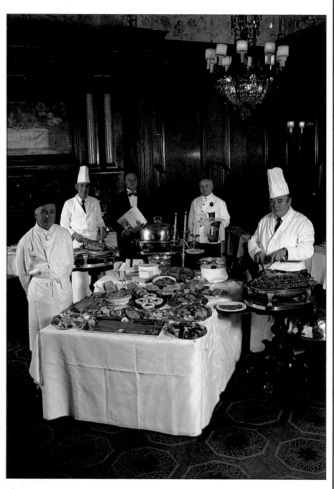

*An oak-paneled room* provides the setting for this formal portrait of staff at a traditional restaurant. The semi-circular composition draws the viewer's eye to each figure in turn, then back to the table in the foreground that provides the focus of attention.

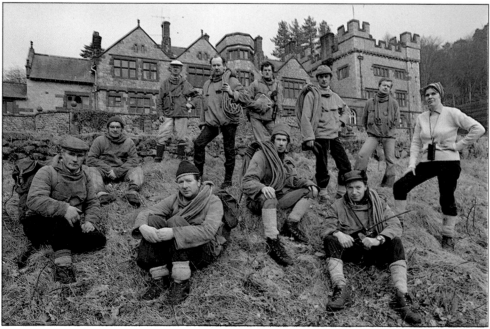

*Eleven mountaineers* give the camera their attention right on cue. By posing the figures a pace apart, the photographer allowed them to express some individuality without losing a feeling of the comradeship that exists within a climbing team.

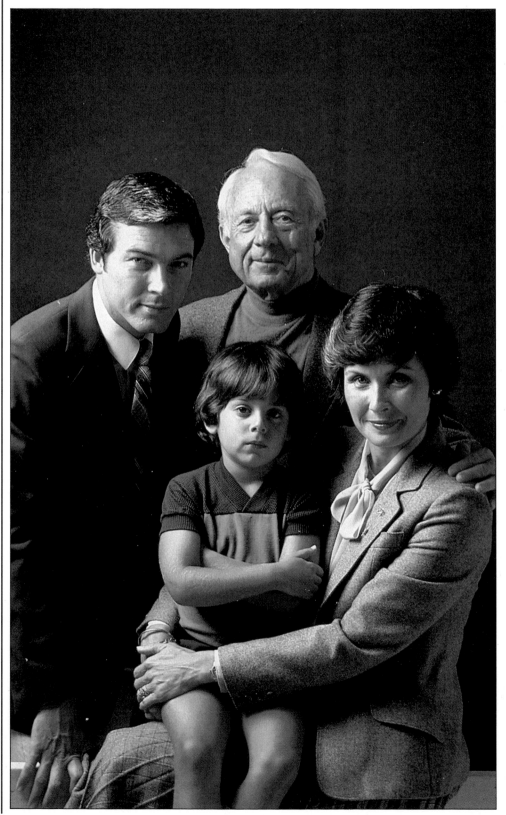

*Three generations* appear in this family group, yet the photographer succeeded in uniting all four of the figures in a powerful composition. Meticulous lighting and a seamless paper background helped (see above), but the picture owes its strength mainly to the curving line of faces and arms that sweeps down, and round to the foreground.

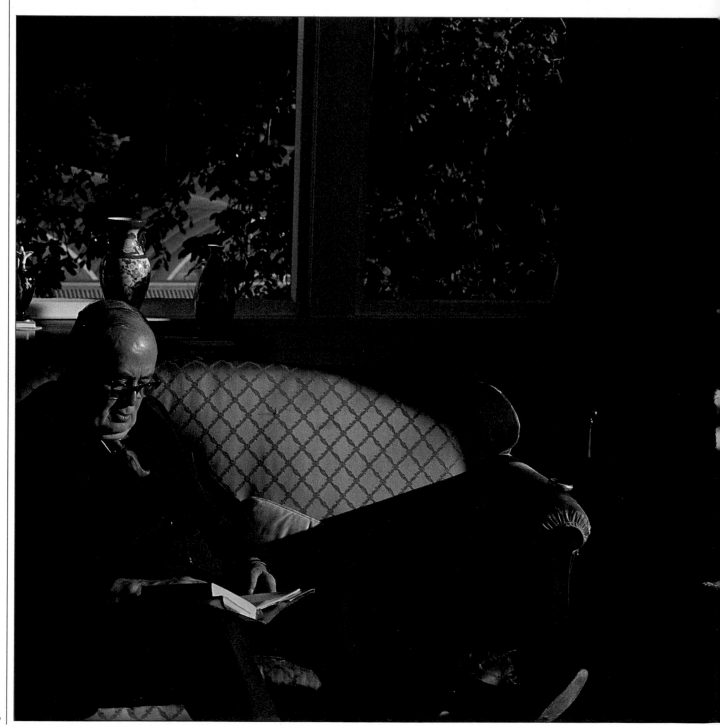

# SITTER AND SETTING

Settings, imaginatively used, contribute enormously to the interest and significance of a portrait. Few people are at ease naturally in front of a camera, so photographing them in their own environment – relaxing at home, as in the picture at left, working or enjoying some leisure activity – makes sense. In addition, surroundings help to reinforce the individuality of your subject.

But establishing a setting for your portrait goes beyond choosing a particular situation and employing a couple of suitable props. When you take a portrait, you are briefly stepping into another person's world. Not only physical possessions, but everything about that person's way of life as presented to the camera can contribute to the story told by an image. What you omit is just as important as what you include, and sometimes emphasizing a single small detail – a ring on a finger or a lock of hair falling over the face – is the only touch needed to bring a portrait to life. This section demonstrates how background, poses, accessories and dress, expressions and gestures, all contribute to an interpretation of personality. By using selective lighting, focusing and viewpoint, and some special effects, you can manipulate and control the various elements in a setting at will, and greatly extend your portraiture range.

*Absorbed in a book* in the comfort of his living room, this man seems unaware of the camera. Positioning the subject at the edge of the frame helped to suggest a deep, undisturbed privacy, and the photographer made skillful use of natural light to show the furnishings without letting them dominate the peaceful image.

# Choosing a pose

Whether the aim of a portrait is to glamorize beauty or to bring out character, the way you pose your subject is crucial. Age, sex and demeanor are all important factors when choosing a pose. To see the truth of this, look at the photographs shown here and then imagine the effect if the subjects exchanged positions with one another. However, several useful guidelines for posing apply to any type of portrait.

First, try to avoid full-face views unless there is a special reason. This approach flatters only some faces. Second, make sure your subject is comfortable. This is particularly important with an older person. Placed in a favorite chair, he or she will automatically settle back into a relaxed position. A chair also provides support for a sitter's arms and helps to solve a key problem: how to pose the hands.

Hands in a portrait need almost as much attention as the face. They immediately betray whether someone is tense or at ease, and they add considerably to a sense of personality. For example, in the close-up at left below, the clasped hands suggest a contained yet dynamic character. A hand supporting the chin, as in the portrait at right below, will help lead the eye to the face.

With a younger person, you can move away from the more sedate and conventional poses. In the picture at far right, the subject twisted round in her chair for a delightfully informal shot. The classic yet casual pose at the bottom of the same page perfectly suits the woman's elegant composure.

*An interlocked position* of the hands, with an index finger pointing toward the camera lens, reinforces the impression of a determined character of powerful intellect. The photographer posed the subject resting his elbows on a table and leaning into a pool of light to accentuate the firmly set features.

*The bookish personality* of an old lady is captured in a pose at her study desk. Seated in her customary chair, she is able to adopt a comfortable, natural position, with both her arms supported. An open book and her scattered papers reflect the gentle, flattering light.

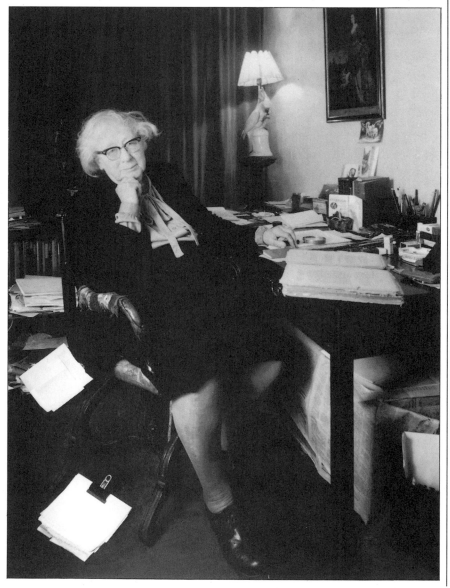

*To convey a kindly authority (left),* the photographer chose a conventional seated pose and a restrained setting in which muted gray tones blend with the subject's formal dress. The folded hands dominate the lower half of the portrait, balancing a formidable, penetrating stare.

*The spontaneity and sparkle* in the portrait above resulted from asking the sitter to swivel her body round to meet the camera. Natural light from the window illuminates her clear profile and gives modeling to the arms and hands.

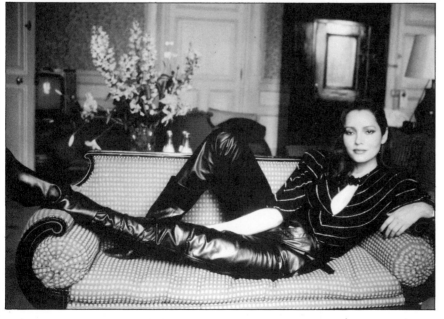

*The confident reclining pose* and direct, assured gaze of actress Barbara Carrera suggest an extravert personality who is completely at ease in front of the camera. An unbroken curve leading from the pointed toe of the boot to the hand accentuates the subject's svelte glamor.

# Faces and features

Each face is unique. A good portraitist trades on this individuality by scrutinizing the sitter's features and then considering how best to present them. Often, successful portraits are not conventionally flattering: but an image that stresses bad features and conceals good ones does no service to a subject.

Two essential things to bear in mind when photographing faces are the structure of the features, and the sitter's expression. The comparative portraits below illustrate how a change of lens, lighting, viewpoint, or pose can enhance a subject (bottom row) by making the most of attractive features and minimizing other aspects. For example, a round face (far left) can be slimmed by concentrating light on the center of the face and asking the sitter to lower the head slightly. Conversely, a broader light on a tilted-up head will widen a thin face. Often the length of

a nose is a problem in portraits. Whereas a normal lens used for a close-up may emphasize or even seem to distort noses, a telephoto lens minimizes this effect. Framing a head to leave some space at the top of the image also helps to make the nose less prominent. To play down a receding hairline (far right), avoid lighting the face from above and behind, which will emphasize the bald area and make the face look out of proportion.

Any of these techniques will be wasted if your subject is not relaxed. When someone is nervous in front of the camera lens, the tension often shows in the eyes or mouth. The result may be a strained, tight smile or a mesmerized stare, both of which kill the most carefully composed portrait. The two picture sequences opposite demonstrate simple ways to obtain a natural expression.

**A round face** (top) viewed head on and fully lit looks too wide. Tilting the head down slightly and reducing the light to a single source (above) shadowed the girl's cheeks and jawline to slim down her attractive face.

**Leaning back** (top) with his head to one side made this subject look heavy-jowled. The photographer asked him to sit forward and smile at the camera; the result was the much livelier and more flattering portrait above.

**The girl's nose** (top) is unpleasantly lengthened by a three-quarter close-up with a normal lens. A full face view with a 135mm lens (above) has the effect of shortening the girl's nose and widening her slim face.

**A balding head** (top) lit from above catches unwanted highlights. By lowering the light source and lens height and getting the subject to raise his head (above), the photographer made the forehead less pronounced.

1

2

3

*Spontaneous laughter*
is difficult to capture in a
portrait. To help this woman
to relax her tense smile (1)
the photographer asked her
to fill her cheeks with air (2),
then blow it out again. The
action is so ridiculous that
it invariably provokes an
outburst of laughter (3).

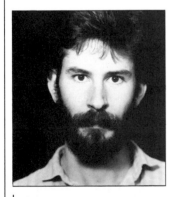

1

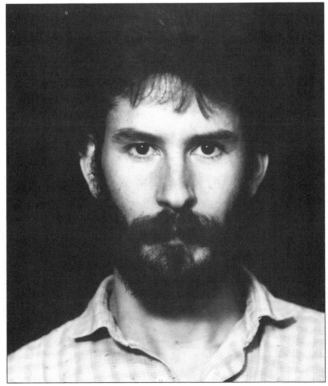

2

3

*A change of glance* breaks
the trance that portrait
subjects sometimes fall into.
To soften this man's fixed
gaze (1), the photographer
asked him to shut his eyes
and look down (2). The final
portrait captures the alert
expression that the subject
wore when he looked up (3).

# Interpreting personality

Getting to the heart of someone's personality is never easy, because each person has a public image behind which the real self shelters. You need to take time to establish rapport with the sitter, so that you can form a clear impression of what you want the portrait to show. Then look for the visual clues – in expression, manner, gesture, dress – that most strongly reinforce this impression.

Using lighting and exposure to create an appropriate mood is an effective way to bring out essential traits, especially when outward appearances mask the person underneath. The portrait at near right uses the clarity of natural light and the tonal simplicity of slight overexposure to convey the wistfulness behind a cool, impassive exterior. And on the opposite page, the richness achieved by slight underexposure suggests deep reservoirs of experience in a thriller writer's face.

One of the best ways to convey the living force of a personality is to make the picture more active by showing someone speaking. In the picture below, a shutter speed of 1/250 captured the sitter when her whole body was concentrating on getting a point across, and produced a telling portrait.

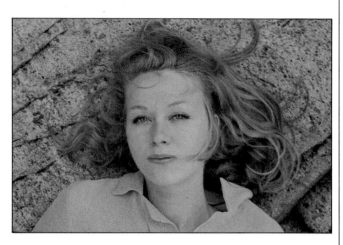

**The tentative gentleness** of the face above would have been difficult to capture in a formal studio setting. Posing the girl outdoors, with her tousled hair spread against a rock, relaxed her, and the high-key image suited her subtle, pale features.

**Dramatic hand gestures** (below) underline the force of this experienced teacher's argument. The photographer waited for the right moment of animation to take the picture – perfectly summing up the woman's articulate and dynamic personality.

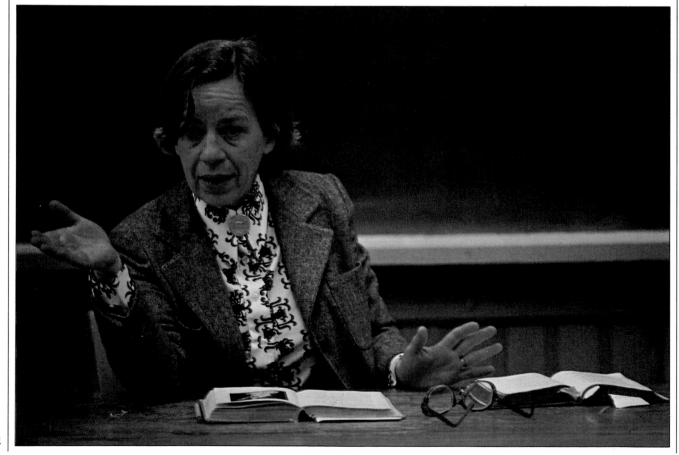

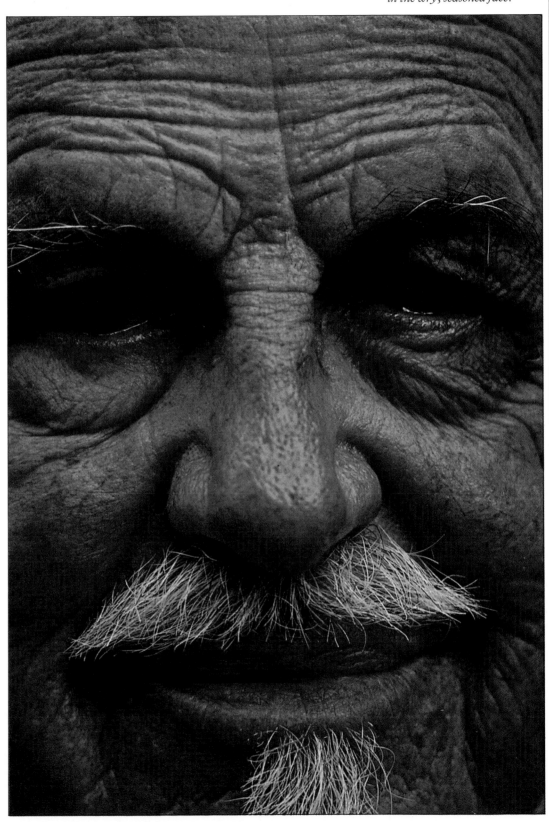

*The genial intelligence* of writer Rex Stout vividly comes out in this penetrating close-up. Strong, diffused sunlight etches every feature in the wry, seasoned face.

# Makeup

There are two reasons to use makeup on a face for the camera. The first is to give definition to good features while minimizing defects. The second is to idealize a face for a fashion or beauty shot. The intention of the procedures being applied to the model on these pages by an expert's hand is to produce a glamorous image. But the basic procedures also apply, perhaps with less emphasis, if you simply want to make a woman look her best for a portrait.

The starting point for any type of makeup is a smooth face. A concealing cream will help to hide skin blemishes, lines and shadows, and powder will reduce shine on oily patches.

Shaping the face, using shading and highlight makeup, is the next step. With shading, you can make features appear more regular, slim down a broad jaw, or shorten a long nose. Highlight makeup, on the other hand, emphasizes features: for example, a highlight down the nose bone will make a face seem longer. To widen close-set eyes, extend eyeliner beyond the outer corners. Outline lips with a lip pencil in a color darker than their natural tone, either slightly inside the natural line or outside, depending on whether you want to narrow or enlarge the subject's mouth.

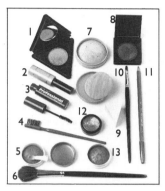

Shade in socket line to make eyes larger

Use concealing makeup to hide blemishes, lines and shadows

Use highlighter to emphasize bone structure and make features more prominent

Extend eyeliner at corners to widen eyes

Use shading to balance the facial proportions and create hollows

Outline lips to improve the shape of the mouth

**Shaping the face**
The diagram above shows key makeup techniques used in the sequence starting below. The makeup kit at left comprises: (1) eye shadow for lids; (2) cover-up cream; (3) mascara; (4) eyebrow brush; (5) eye shadow for sockets; (6) blusher brush; (7) foundation; (8) eyeliner; (9) foundation sponge; (10) lip brush; (11) lip pencil; (12) lip gloss; (13) blusher.

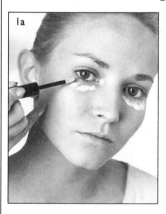

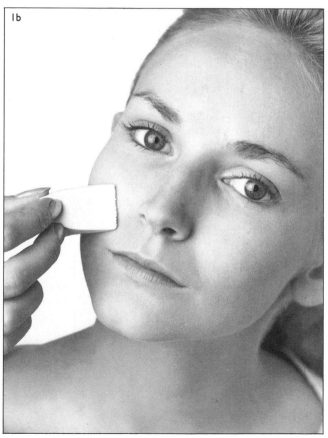

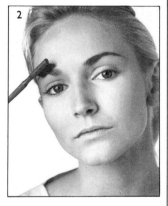

*1–A good foundation for makeup is always essential. Use concealing cream (a) to cover spots, lines or bags under the eyes. Then evenly apply mat cream makeup to the face with a sponge (b). Choose a shade close to the subject's skin tone and blend in well. Lightly dust on translucent powder with a puff or brush to set the makeup and give a smooth, mat skin texture.*

*2–Define eyebrows by brushing on soft color. Use short, feathery strokes and follow the natural arch of the brows. Be careful not to make the eyebrows too dark in relation to hair color.*

**3–Use eye makeup** so that the eyes look larger. Start by painting a fine line along the lower lid (a), close to the lashes and extending to the outer corner. Then paint another line along the top lid (b), widening it toward the corner and extending it to meet the bottom line. With a lighter color, brush shadow into the socket line (c); use a finger to soften the line. Apply mascara (d) to top and bottom lashes; powder lightly and reapply when dry.

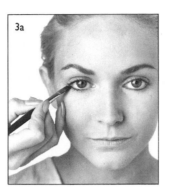

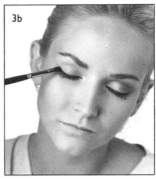

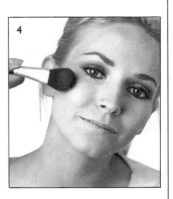

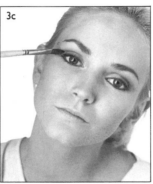

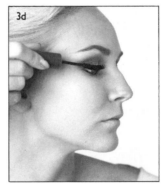

**4–Stroke on blusher** with a large, soft brush applied just below the line of the cheekbones. Use a sweeping, upward movement; do not apply the color too heavily, or the face will appear gaunt.

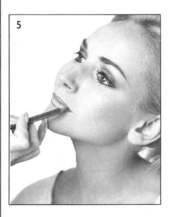

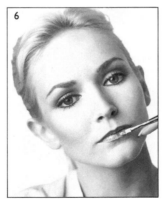

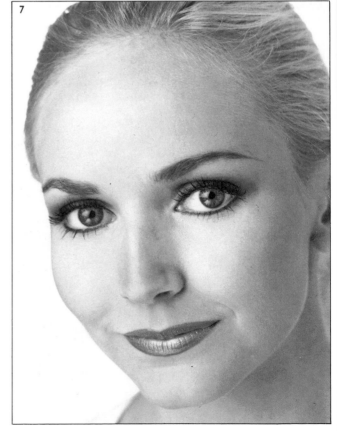

**5–Outline the mouth** neatly with a fine brush or lip pencil using a slightly darker shade than that of the main lipstick color.

**6–Fill the lip outline** with lipstick; use a brush to apply the color smoothly. To give a natural shine, finish with a light coat of lip gloss.

**7–The finished face** displays a smooth, flawless complexion and well-modeled contours. The eyes and mouth are glamorously accentuated without appearing unnatural.

# Hair

Hair often needs special attention in a portrait, particularly when the person you are photographing makes it an important feature of her (or his) appearance, as the girl opposite clearly does. In the wrong lighting, a photograph can make the most lustrous hair look lifeless. Yet the semitranslucent quality of hair – and the movement imparted by a shake or turn of the head – mean that you can use it in a unique way to bring a portrait alive.

The tendency is for people to want to tidy their hair for a picture. This is not always a good idea if you want a natural effect. Certain high-fashion photographers often take great care to wash, set and otherwise prepare hair. But if you are photographing a woman with clean, attractively styled hair, you can ensure that her hair has sufficient body simply by asking her to put her head down and then swing it back again, thus letting air fill out her hair naturally. A sudden turn of the head, as in the picture at bottom right, will give hair movement. Alternatively, you can make use of a breeze outdoors or create a draft indoors.

Careful lighting shows beautiful hair at its best. All colors of hair except the palest blond absorb a lot of light and indoor portraits look better if you direct an extra light onto the head with a spotlight or a floodlight narrowed by a snoot. Backlighting with either sunlight or artificial light is a classic way to emphasize hair, creating a halo effect, as shown in the two pictures below.

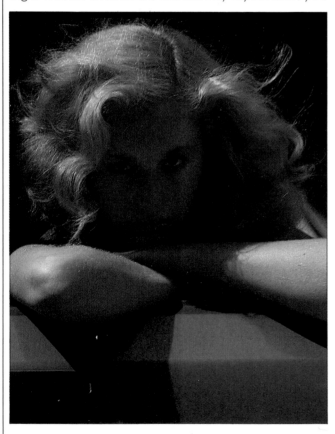

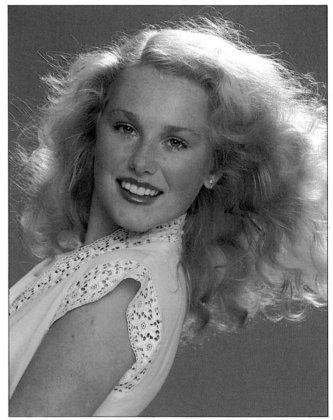

*Leaning on a car door,* this girl seems bathed in golden sunlight. By moving her so that the light shined through her wavy hair from behind, the photographer emphasized its fine quality and ash-blonde color. Her bare arms reflected light back into her face.

*An indoor portrait* shows how backlighting can add brilliance to hair in the studio (above). A single spotlight (diagrammed) created the soft, glowing halo while a diffused floodlight to one side of the camera provided the main lighting.

*A mane of thick hair* is made even more dramatic *(below)* by the choice of an apple-green background and by a pose that emphasizes the hair's weight and length.

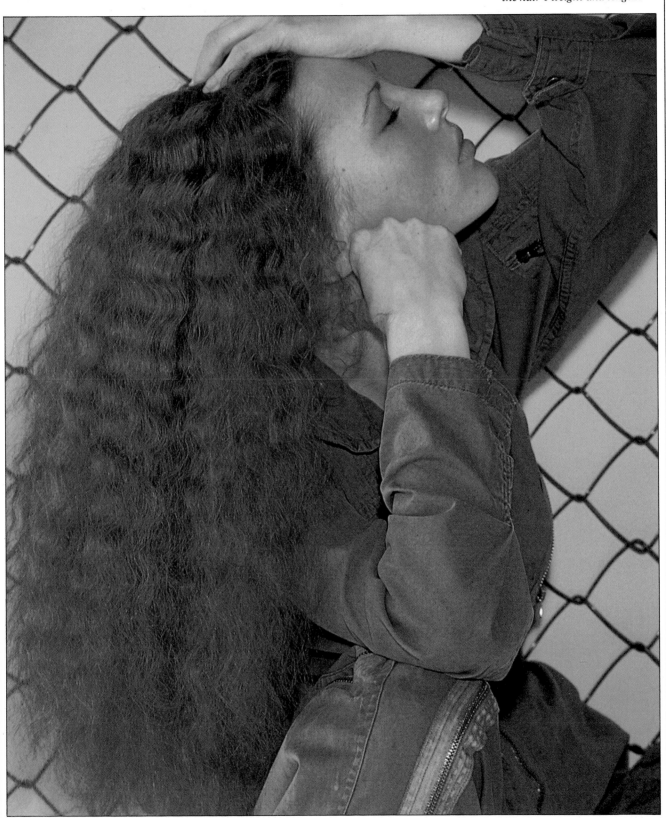

# Props and accessories

Certain accessories can become extensions of the people associated with them. An obvious example is a pair of glasses; their wearer may be almost unrecognizable without them. A small girl may look most like herself when she is clutching her teddy bear. A man may even seem naked without his pipe. Other personal effects similarly reveal people's tastes, interests or achievements, and all of these props can help you build up a rounded portrait.

At a subject's home you will have a wealth of props from which to choose: almost everything you see will provide some clue to a facet of personality. The temptation is to include too much. But a few

items, positioned carefully, will support the portrait best, especially if you can make them all work together. For example, in the picture at right below, the painting and chessboard are strong elements suggesting the varied cultural interests of a noted writer; the dog adds an informal, domestic touch.

Props can also reinforce a subject's professional or public image. The two photographs on the opposite page show how including the equipment of working life in a casual way can add to the authenticity of a portrait. At left below, portraits within a portrait provide a parallel between private and public lives and also give the picture a time scale.

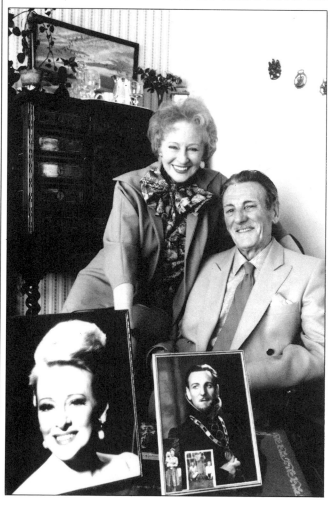

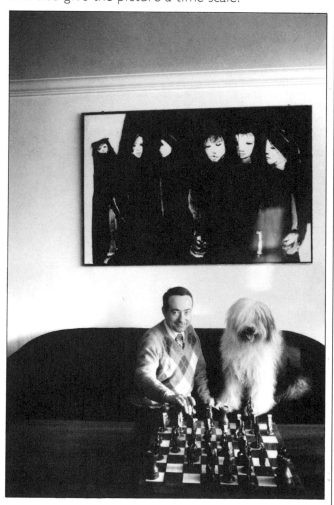

*Framed portraits of singers Anne Ziegler and Webster Booth command almost as much attention as do the subjects themselves. This imaginative use of foreground props reveals the special bond linking the pair, and the two glamorous photographs also show how little the couple have changed.*

*Writer George Steiner plays a one-man chess game, apparently watched by his shaggy companion and the faces in the painting behind. This quirky use of props serves to draw together all the supporting elements in the portrait, and pointedly suggests the witty, original intellect of the man himself.*

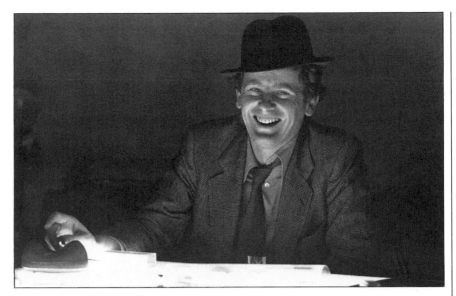

*A lighted viewing box* for slides puts a journalist in a professional context and provides brilliant spotlighting that suits his jokey, extravert features. The jauntily-perched hat adds to the sense of a happy-go-lucky personality.

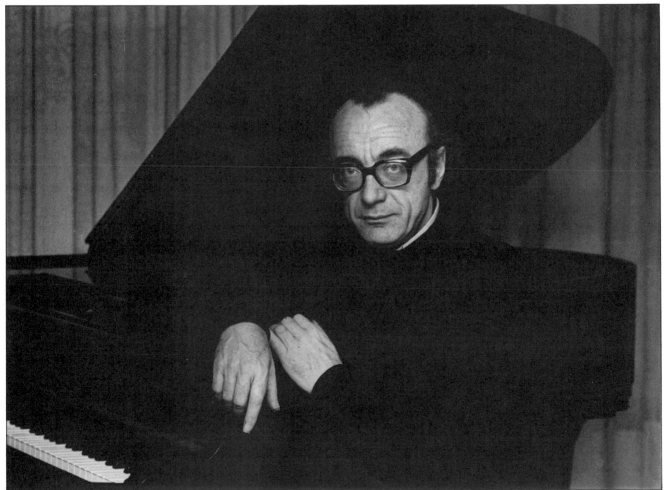

*Concert pianist Alfred Brendel* rests a possessive arm on his piano. The merging of the piano and the subject's clothing convey his identification with the instrument and the dark tones isolate the portrait's main elements: the strong face, the sensitive hands and the line of the ivory keyboard.

# The importance of background

The tone, color or character of a background can influence a portrait both visually and psychologically. Dark backgrounds tend to dramatize the subject by tonal contrast or to suggest a serious or assertive personality. Light backgrounds set up a more relaxed feeling and usually create portraits of greater charm and frankness. Bear in mind, too, that bold colors will give a portrait a more vibrant feeling than will subdued hues, although a major consideration in choosing background colors is the way that they suit the subject's hair or clothes.

For indoor portraits, try to select a suitable background ahead of time – or provide one yourself by visiting a photographic supplier and buying a roll of seamless paper. You can make a lightweight frame of wood to support the roll, which should be at least eight feet wide. To prevent background paper from looking too artificial, you can introduce some tonal variations by lighting the background unevenly, perhaps from below. If you do not want to fuss with special lighting, vary the backdrop by patchily paint-ing or staining it. As the examples below show, if you change backgrounds and colors, the effects obtained can be strikingly different.

By using the interior decor of a room as a background, you can introduce elements more directly relevant to the subject, as in the picture of the woman opposite. Place the subject close to a background you intend to feature, which may appear dark if too far away. Alternatively, light the background separately – plenty of background light, with less on the subject, can give the pleasant, high-key effect of a very bright room. Use the camera's preview button to ensure that you have stopped down enough for both subject and background to be in sharp focus.

With outdoor portraits, do not include more detail in the background than you really need. A plain wall, a bank of foliage, or even a solitary tree trunk will do. The picture of the sea captain opposite includes just enough of the ship's hull and the anchor to establish the context – but no more.

*1 - A green background begins this sequence of portraits. All show the same subject but each establishes a wholly different effect largely because of the background chosen. Here, canvas casually painted soft green seems to suggest a relaxed and gentle mood.*

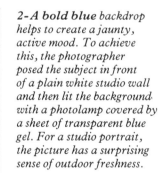

*2 - A bold blue backdrop helps to create a jaunty, active mood. To achieve this, the photographer posed the subject in front of a plain white studio wall and then lit the background with a photolamp covered by a sheet of transparent blue gel. For a studio portrait, the picture has a surprising sense of outdoor freshness.*

*3 - A glossy red wall has an up-beat effect, which the subject matched with a challenging pose. The yellow T-shirt and scarlet lipstick coordinate with the wall's vibrant color.*

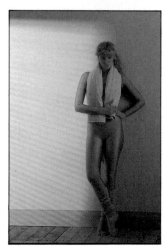

*4 - A shadow from a window blind falling across a gray wall, and natural light on the subject help to create a softly romantic atmosphere. The gray dance costume and headband also play a part in the subtle color harmony.*

*A woman administrator* (right) stands in front of massed portraits of her male predecessors in the Chicago Board of Education – and makes a telling portrait.

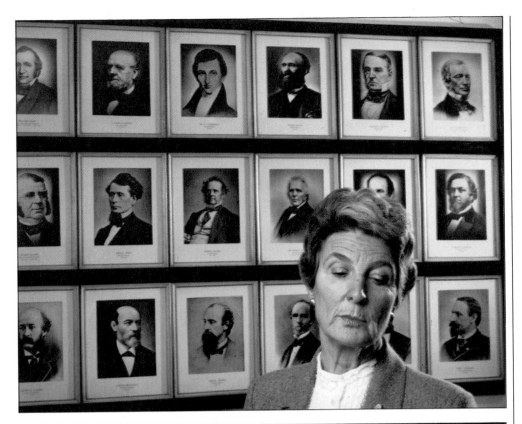

*A sea captain* (below), sitting on the dock beside his ship, quietly lights his pipe. Rough steel, rusting anchor and a painted letter form an entirely appropriate and attractive backdrop.

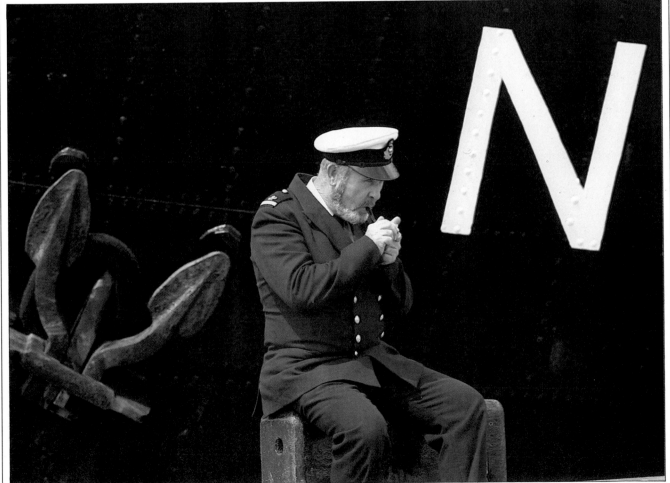

# Indoor settings

Rooms come to reflect the personalities of those who live or work in them. This is as true of people whose rooms are bleak and spartan as of those who fill them with whimsical odds and ends. In many portraits you can use an interior as a major component of the picture, not merely as a backdrop.

In the picture below, the chaotic jumble in the studio of the painter Francis Bacon suggests the fierce obsession of an artist and his indifference to conventional ideas of tidiness. In striking contrast, the neatness of the room shown in the sequence of pictures at the top of the opposite page reveals the fastidious character of the subject, whose books are arranged in precise sets behind him.

In any indoor setting, decide first what area of the room best supports the point you want to make about the subject. Then, with the subject in place, consider the lighting and composition, if necessary shifting the position of objects (and of your photographic equipment) until you are satisfied. It often helps to switch on table lamps or light a fire to give a warmer effect. Remember that foreground objects may have a disproportionate importance in the image, especially if you are using a wide-angle lens to encompass the surroundings. You may need to move some furniture to overcome this. With a subject fairly close to the lens, be careful that feet or knees do not loom too large.

If you want a completely controlled formal portrait, use a tripod. This will allow you to look carefully at the whole image from a fixed position and attend to such details as keeping door or window frames vertical. A single detail, such as a newspaper, that might add the perfect finishing touch to a portrait could spoil the whole effect if carelessly placed.

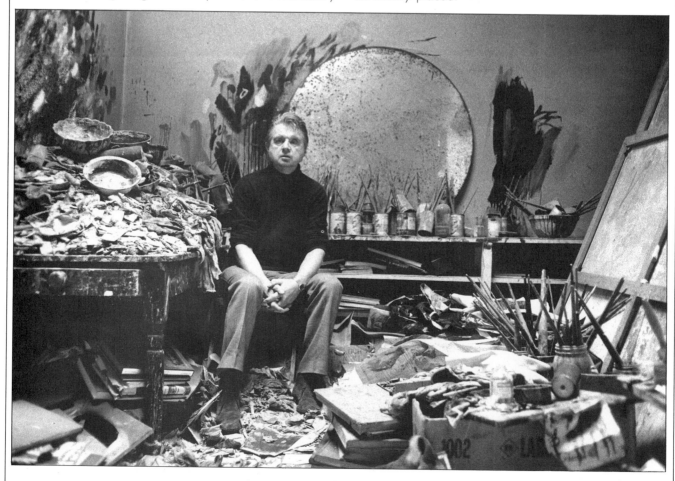

*Francis Bacon's studio, encrusted with used paint tubes, rags, newspapers and brushes, provides an ideal eccentric setting for this extraordinary artist.*

**1–With a bookcase as a backdrop,** the photographer has given this elderly man a scholarly image, even though he looks an outdoor type. The simple clues offered by the setting suggest the complexities of his character.

**2–With more of the room** in the frame, we also learn that he lives in elegant, if somewhat austere, surroundings. This more detached view seems to suit the subject, and the additional details of his home environment extend our knowledge of him.

**3–Moving back** farther into the room, the photographer included foreground elements that shift the balance of the picture more toward the character of the room itself – a domain in which the occupant can feel completely self-assured.

1

2

3

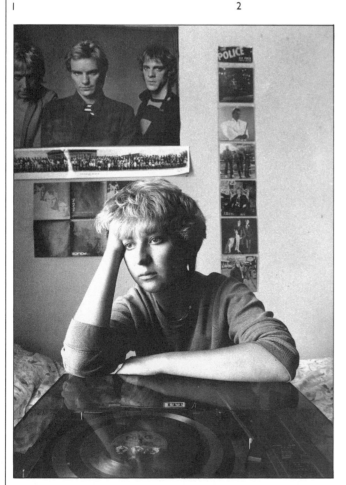

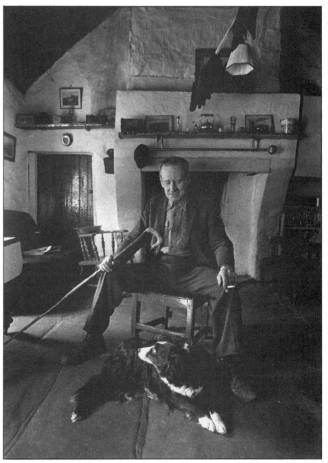

**Alone in her room,** a teenage girl stares into space. The photographer used her private environment to catch a characteristic mood of adolescence.

**An Irish sheepdog trainer** sits in his stone-flagged cottage, accompanied by a favorite dog. Here, the setting helps establish a whole way of life.

# Outdoor settings

The excellent lighting conditions to be found outdoors allow you to take advantage of an enormous variety of potential portrait locations. In many ways, the most rewarding approach is to place subjects in landscapes (or city streets if you prefer) with which they have a direct and significant connection. For example, a famous playwright, Alan Ayckbourn, is shown at right sitting on the beach at the seaside town where his comedies habitually open. A wide-angle lens is useful in this kind of plain setting, giving broad depth of field beyond the central figure.

Using a setting to support the subject also works at someone's home, where the backdrop of a house or garden adds information about the person who lives there in much the same way as does an interior. The picture of mother, daughter and cat below includes just enough of their well-kept garden to suggest a full and energetic family life. In an entirely different context, the portrait of the owner of a French château at the top of the opposite page projects a flamboyant, larger-than-life personality who unashamedly enjoys a grand lifestyle.

When you do not have a specific message to convey through the outdoor setting of a portrait, try to keep the background simple. An attractive landscape that bears no direct relation to the subject may add depth and interest to the picture, but is equally likely to prove a distraction. To prevent this, choose viewpoint carefully or use a telephoto lens to narrow down the view and exclude unwanted foreground and background details.

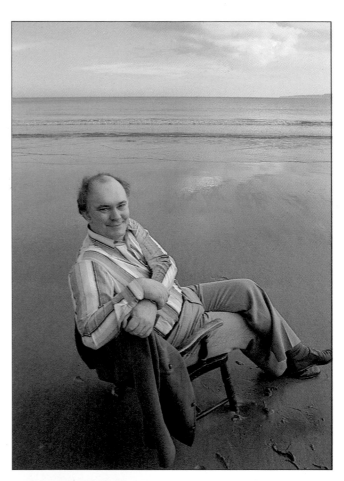

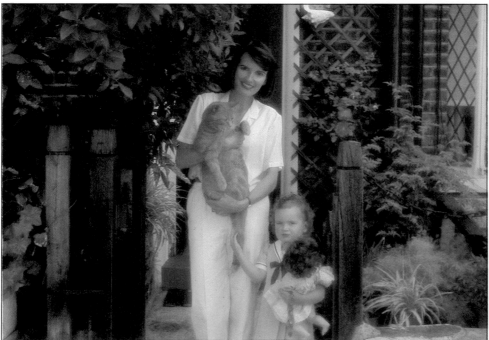

*A beach portrait* (above) shows how you can use the setting as a significant, but subsidiary, part of the picture. The pose suggests that the subject has been looking out to sea and has just turned to the camera.

*A young family* (left) blends softly with the plants of their suburban garden. The photographer breathed on the lens before taking the picture to achieve the slight soft-focus effect.

*A swimming pool* (right) makes a brilliant background for an actor's portrait. The photographer controlled the sun's dazzling reflections by fitting a polarizing filter to a 135 mm telephoto lens.

*A wealthy businessman* stands on the steps of his grand château. By centralizing the composition, the photographer has given emphasis to the solitary figure.

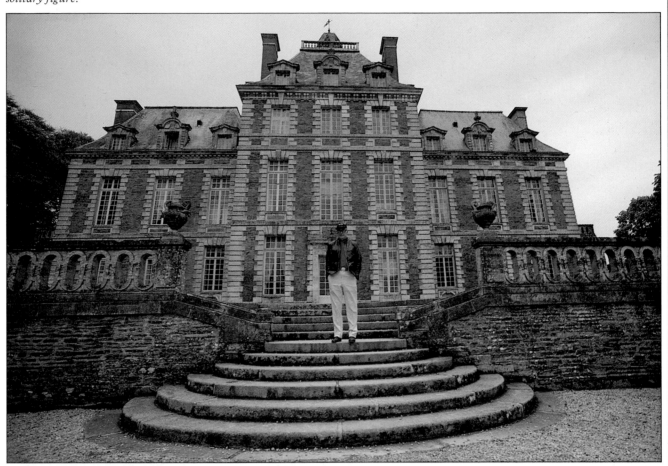

# Movement and gestures

Through gestures and expressions, people often reveal more about themselves than they realize, particularly if they are relaxed, or engrossed in conversation. Thus, by getting your subject involved in a discussion, especially on a controversial topic, you can draw out expressive movements and emphatic poses such as those shown at right and below. The presence of a third person to carry on the conversation will help. But failing this, it is not difficult to talk and take pictures at the same time. Fix the camera on a tripod, and look through the viewfinder to make sure that movement will not carry the subject out of the frame, then preset the focus and exposure controls. Having done this just once, you should be able to stand alongside the camera and release the shutter confidently without breaking the conversation by bending down to look through the viewfinder.

Some very self-assured poses, such as that of the film star Joan Crawford at far right, point emphatically to the character of the person portrayed. Often such revealing poses pass before you can release the shutter, but there is no harm in asking someone to repeat a particular gesture. Everyone has something of the actor in them, and only the most self-conscious sitter will find such a request impossible.

If you want a flamboyant portrait and the subject is uninhibited, you can create an image with an expressive, fluid line, as the photographer did in the picture at the bottom of the opposite page by asking the subject to sweep a scarf around her. A shutter speed of 1/4–1/15 will blur body movement but keep a stationary face fairly clearly defined. A dark background helps, because the blurred movement then stands out clearly against it.

*A relaxed smile* (above) and a jauntily angled hand identify a man who is at ease in front of the lens – hardly surprising as he is himself a photographer. You may have to coax less self-confident subjects to get them to repeat their normal gestures for the camera.

*Successive frames* (below) from a single roll of film show an actress using bold gestures for emphasis and punctuation. Compared with conventional static portraits, these theatrical, gesticulating poses seem much more expressive, interesting and alive, conveying a vibrant and colorful personality.

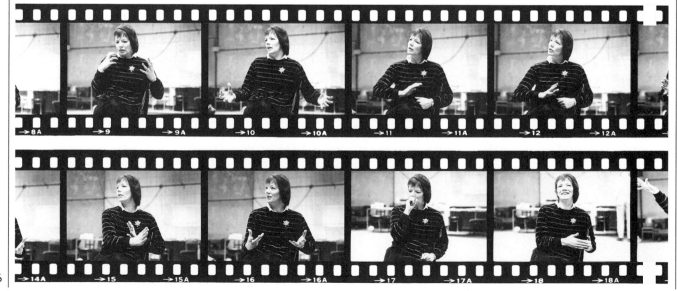

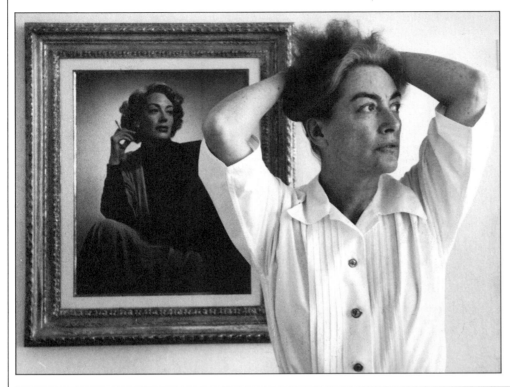

*A star's assurance* comes across as *Joan Crawford* ruffles her hair with brisk impatience. The gesture encapsulates the strength that characterized many of the roles in her long career.

*A sweep of the arm* and loose, flowing clothes give this woman's portrait a balletic grace. When you set your camera to a slow shutter speed, walking and running figures often take on a similar dreamlike, ethereal quality.

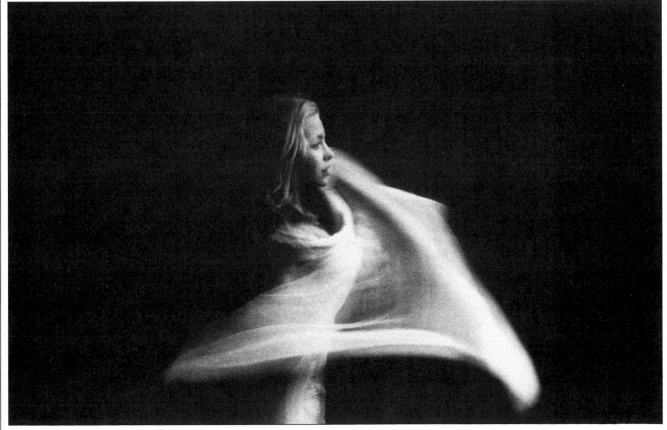

# Mood with color

An excellent way to establish atmosphere in a portrait is to build the picture around a particular color scheme. Colors linking your subject with his or her surroundings help to unify and strengthen the whole image.

In choosing a theme, you need to bear in mind the psychological values of different colors, and the effect you want to create. For example, soft pinks and greens may suggest a delicate femininity, especially in a high-key portrait; a red setting may dramatize a dark-haired beauty; rich blues or purples may give the same subject a moody sophistication, as at right. Whereas vivid, saturated colors in juxtaposition will convey a restless, lively personality, more subtle combinations set up quieter

moods. In the understated portrait at the bottom of the opposite page, the neutral browns, grays and beiges create a dignified atmosphere without being obtrusive. At the other extreme, you can exploit special effects to make color distinctly unnatural. The bold and amusing fluorescent image below is a striking example.

For portraits indoors, the simplest way to establish a color scheme is to begin with the subject's clothing – perhaps accentuated by accessories – then set up a background that matches. When you are using brightly colored backgrounds, always watch out for light reflecting off the colored area onto a subject's face. Greens or reds especially can give an unpleasant tinge to the skin.

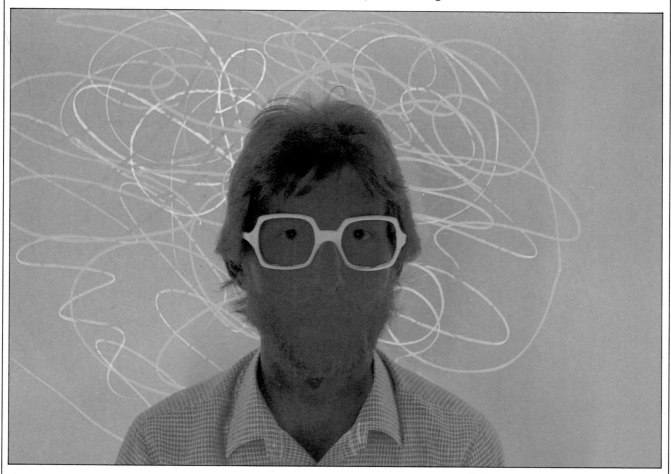

*Ultraviolet light* from a black-light tube picks up fluorescent paint on a pair of glasses and luminous background squiggles. The photographer used daylight film and shined a flashlight covered with a red filter.

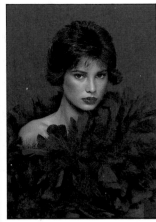

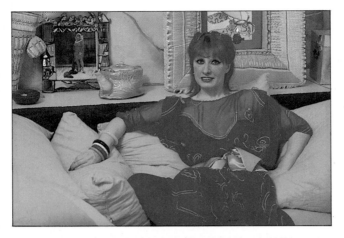

*Vibrant primary colors* (left) reflect the original tastes of fashion designer Zandra Rhodes. The color matches between furnishings and details of clothing give harmony to the composition.

*Jewel-rich blues* create a mood of sensuous opulence in the portrait above. The girls's glossy, crimson lips provide a brilliant color accent that helps to focus attention on her features.

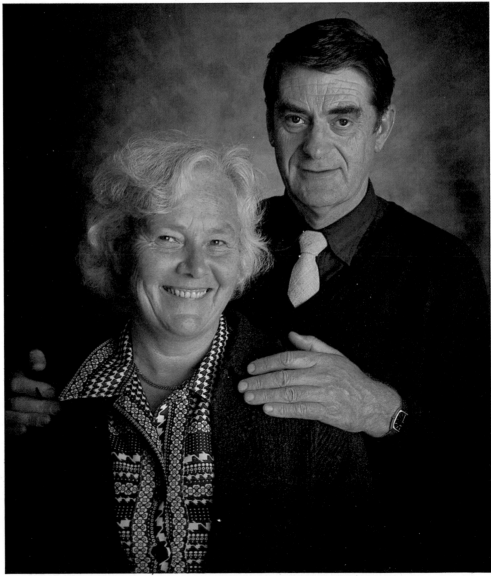

*The restraint* of a neutral color scheme (right) suits the quiet intimacy of this affectionate portrait. Muted hues flatter the couple and suggest their reserve.

# Using reflections

Reflections add interest and complexity to portraits. For clear reflected portraits, a mirror is usually best. But any number of other polished surfaces can provide intriguing dark images – for example the table top in the picture of the rabbi at right below. Outdoors, shop windows, the polished chrome of cars, or even the water of still pools can be sufficiently reflective.

In photographing a mirror-reflected portrait, take the picture at an angle to the mirror's surface to prevent either yourself or the camera from appearing in the picture. The simplest approach is to place the subject close to the mirror or even touching its surface, as in the picture of the girl at left below. You can experiment with different views, but as a starting point position the camera at a 45° angle to

the mirror and then ask the subject to look into the mirror at the camera's reflection. This gives you a three-quarter view of the face – plus the reflection, which appears to look straight at the camera. Because light has to travel from the subject to the mirror and then to the camera, if you want both subject and reflection in focus, you may need a small aperture to achieve sufficient depth of field for both.

You must also be very careful not to catch room lights or photographic lights in reflective surfaces. This is especially true with flash, when you may be unaware that the light is bouncing directly back from the mirror into the lens and spoiling the picture. Lights should shine on the subject rather than on the mirror. Look carefully in the viewfinder to make sure you cannot see any reflected glare.

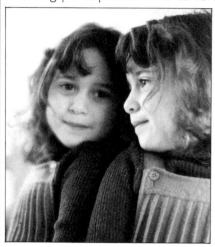

*A little girl* standing by a mirror *(above) presents two views of herself to the camera. By focusing on the real girl and using a large aperture, the photographer put the reflection slightly out of focus for a soft effect. The girl and her reflection have about equal emphasis with this approach.*

*A highly polished library table (right) produced the reflection of this grave Israeli rabbi at his studies. The large book with which he is working bounces the light from a window back onto his face and softens the shadows. The upside-down reflection, darkened by the wood of the desk, is subsidiary to the main point of interest – the face.*

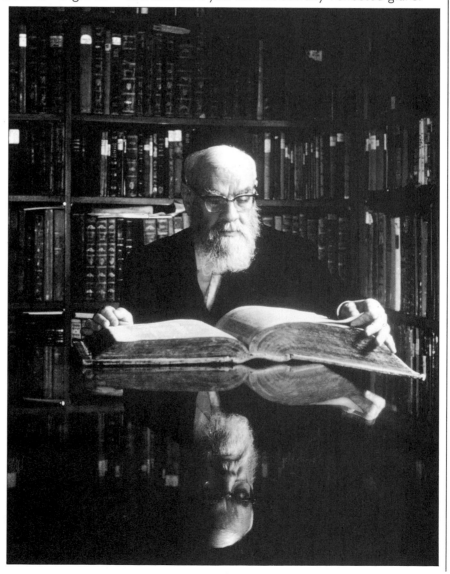

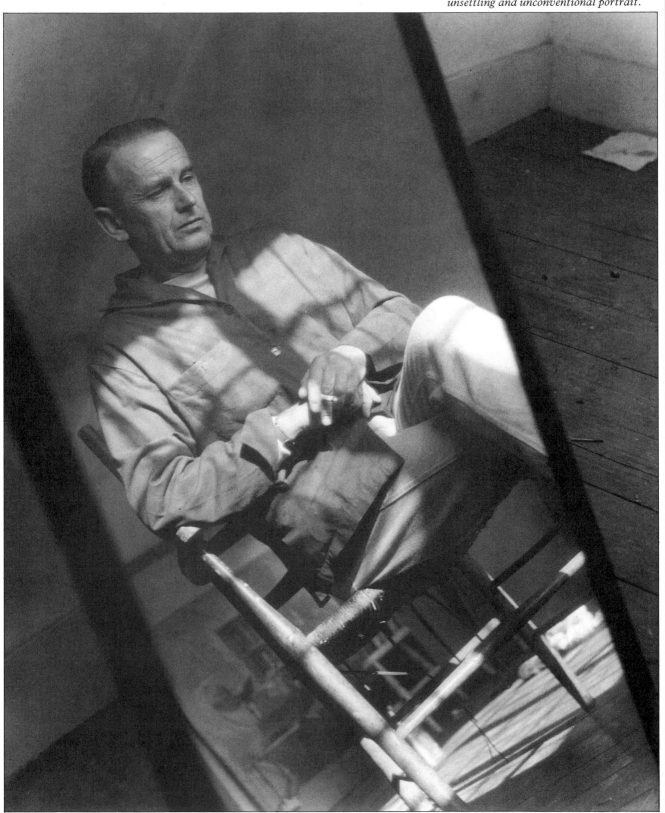

**Bizarrely tilted** by reflection in a sloping mirror, the painter Graham Sutherland seems lost in thought. Here, the photographer effectively used the reflection of the subject alone for an unsettling and unconventional portrait.

# Double exposure

Double or multiple views of the same person achieved by exposing a single frame more than once are intriguing. But they require careful planning and some practice. They work best against a dark background, preferably plain black. This way, a semi-transparent image of the background will not appear superimposed on the subject when you make the second exposure. Unless a ghostly effect is calculated, as at the bottom of the opposite page, a background overlap can simply look like a mistake.

Double exposures are easiest to control. with large-format cameras that do not advance the film automatically and which have focusing screens on which you can trace with a wax crayon the exact position of images for each exposure. However, you can make double-exposed portraits with a 35mm camera by applying either of two techniques. One method is to put the camera on a tripod at night or in a dark room and set a time exposure. Take the lens cap off briefly and fire a flash unit twice with the subject in different positions, as at near right.

A more flexible approach is to disconnect the mechanical link between the film-advance lever and the shutter-release button. This link, designed to prevent inadvertent double exposures, can be freed on some cameras by means of a multiple exposure button. But you can disconnect it yourself, as diagrammed and explained at top right on the opposite page, by using the camera's rewind knob and advance release button to free the film while operating the wind-on lever between one exposure and the next. With a dark background, you should be able to position your subject accurately enough to achieve clearly separated images, especially if the subject also wears dark clothes, as in the multiple exposure below.

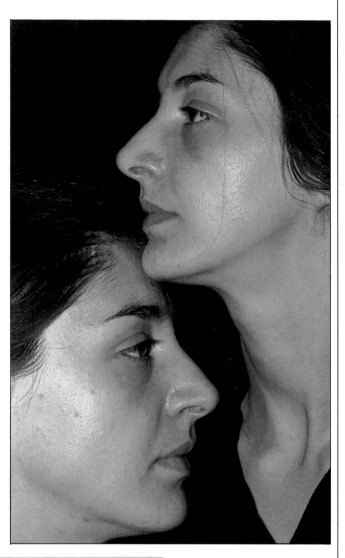

*A double profile* (above) displays both sides of the same face. The woman turned around and posed slightly higher for the second of two flash-lit exposures against a black background.

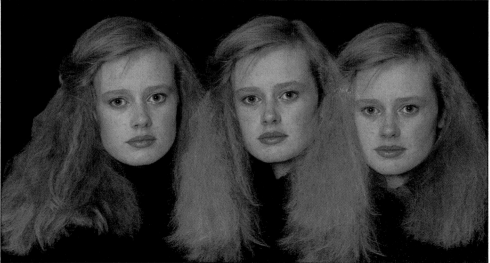

*The triple image* at left was plotted on the focusing screen of a large-format camera to achieve a perfect arrangement of the subject's hair. Dark clothes are best for such well-defined images.

*A split personality is suggested by the overlapped images of this woman. To heighten this uncanny effect, she changed into white for the second exposure.*

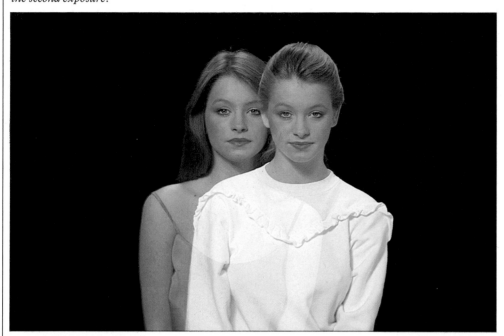

### Exposing a frame twice

To free the shutter release on a 35mm camera for a second exposure, turn the rewind back to tighten the film (thumb at right). Then disconnect the film from the forward wind by using the advance release button (here on the camera front but often on the top or base). Maintain pressure and crank the lever forward with your other thumb.

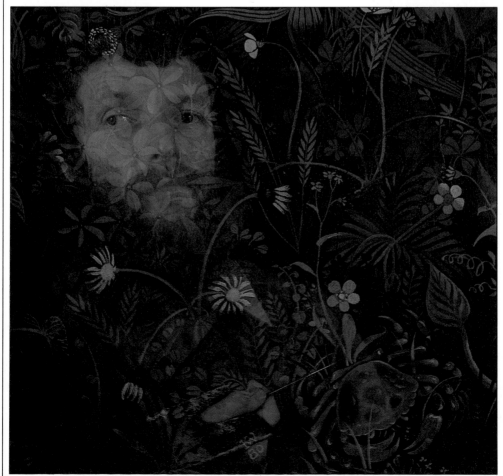

*The ghostly image of an artist appears out of the twining flowers and leaves of one of his own paintings. The photographer first made an exposure of the painting alone, as shown below. Then on the same film frame he photographed the artist against a black background.*

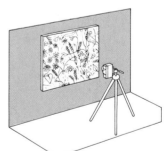

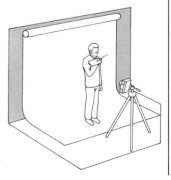

# The art of concealment

Sometimes a half-concealed figure or a glimpse of a face says more than a straightforward portrait does. For example, the picture below does not show clearly the features of the young woman at the foot of the stairs but does evoke a common human anxiety about moving to a new home. In such portraits, the story-telling element is more important than is identification.

Here the photographer used a long exposure so that movement would blur the woman's face. But this is only one of many tricks of concealment that can make portraits more intriguing. You could make use of obscuring foreground objects to establish different moods – the soft flowers in the picture at near right, or the craggy rocks below it. Or you could break up the image of a face with drops of rain spattered on a window. Such techniques allow you to reveal as much or as little of the subject's physical appearance as you choose, and leave viewers free to imagine the rest.

One way to hide much of a subject yet still convey a strong impression of personality is to make sure that you include the most evocative part of the human face – the eyes. In the picture at far right, the girl's eyes are eloquent even though the rearview mirror shows only a narrow slice of her face. Alternatively, you could spotlight the eyes in an otherwise shadowy face, or isolate them by photographing someone through the bars of a screen or the slats of a Venetian blind.

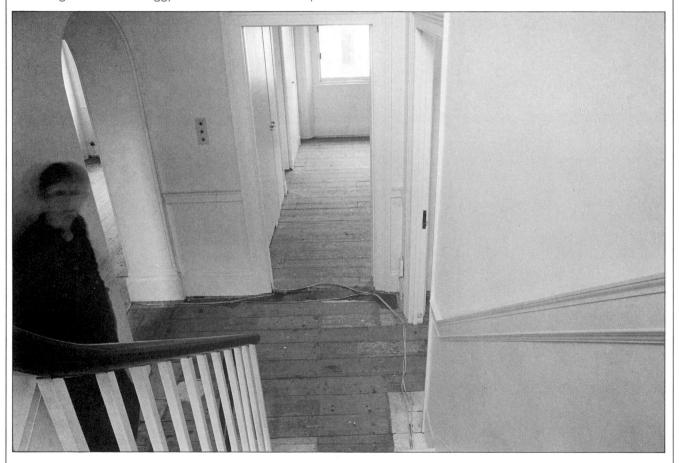

*A half-ghosted face glances up at the camera. To strengthen the uneasy mood, the photographer chose a high viewpoint, and positioned the figure at the edge of the frame. Slight movement, and a shutter speed of 1/15 caused the blur.*

*Sitting on a staircase,*
*a young woman seems to*
*invite the viewer to pass*
*beyond the out-of-focus*
*flowers that softly shield*
*part of her body.*

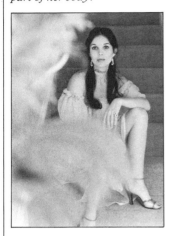

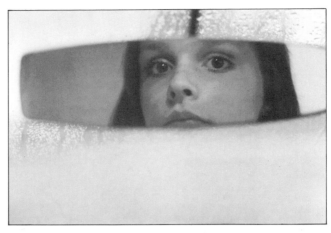

*A rearview mirror*
*reflects just part of a face,*
*yet the portrait appears*
*to be surprisingly complete,*
*perhaps because the view is*
*familiar to any car driver.*

*Rugged, encrusted rocks*
*draw attention forward to*
*this man's face, suggesting*
*his strength of personality*
*although only a small part*
*of his physique is revealed.*

# Portraits at play

Pictures of people at play are not portraits in the conventional sense of a sitter and photographer facing each other across the camera. But with a willing subject, you can make a picture that has the appearance of spontaneity although the image is just as planned as is a more formal portrait.

If people have skills or abilities of which they are justly proud – as has the seasoned fisherman at right – then some subtle flattery may help to win their cooperation. With a little persuasion, most people will re-enact an activity for the camera, and even go more slowly through the motions of what they are doing in order to help you secure a better portrait.

Before you intervene with your camera, sit quietly and assess what you want to show. Often, one aspect of someone's activity looks particularly

attractive, and you may want this action repeated so that you have several chances to photograph it.

The natural rhythm of many organized games or sports will bring the participants back repeatedly in front of a planned camera position. Other leisure pursuits involve more random movement. For example, much of the spontaneous energy of a child's play disappears if you attempt to control the game, and you cannot get a creature such as the parrot in the image below to repeat an action or pose. Under these conditions, there is no alternative but to follow the subject through the viewfinder and take several pictures as soon as everything looks right. Although this demands patience, it may be the only way to catch a relaxed, natural portrait of someone completely absorbed in an activity.

*A child at play (left)* soon ignores the camera, and thus such portraits have an animation that more formal images often lack. Here the photographer used a 135mm lens to avoid a soaking.

*Jumping in the air (right),* like any other activity, makes people relax for the camera. Such warm-up routines often provide a rich source of lively images – and also make good preludes to formal portraits.

*A tame parrot (left)* adds a bright splash of color to this portrait. Similarly, any pet, such as a cat or dog, can be used to draw the subject's attention away from the camera and create a more relaxed picture.

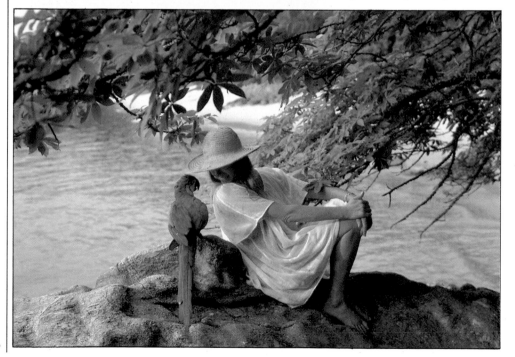

*Fishing in the sun (right),* this man concentrates all his attention on casting the fly. A 28mm wide-angle lens gave the photographer the field of view to capture both the absorbed subject and his patient companion.

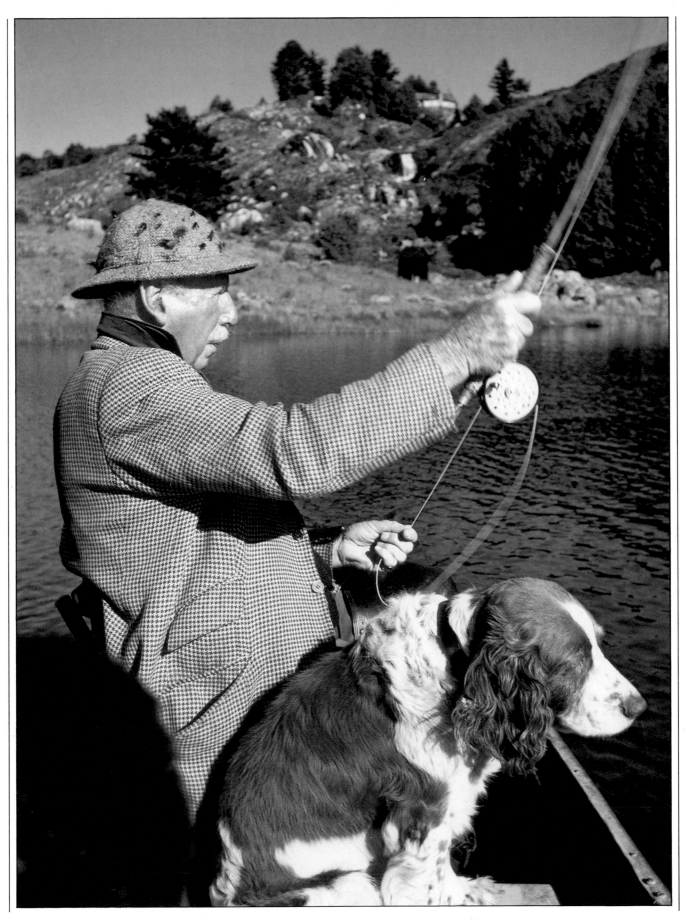

# Portraits at work

Portraits of people at work can reveal aspects of character in a unique way. A man who works in an office, in a factory, or on a farm probably spends half of his waking hours in a single environment. What he does may give shape and meaning to his whole life – so much so that you would give a false picture of him if you photographed him in his best suit in the isolation of a studio.

Because portraits at work usually require the cooperation of an employer or fellow workers, you should do all you can to avoid disrupting the day-to-day routine. Keep your equipment and photographic technique simple and use the available light from a window if possible. This has the added advantage of retaining the true atmosphere of the workplace, which is often lost if you introduce additional lights. A fast black-and-white film will give you maximum flexibility, and also avoids the problem of unnatural color casts from the mixture of lighting often found in workplaces.

In most work situations you will have to accept the surroundings that you find. Sometimes these will give strength and authenticity to the picture. If not, you can control an unsuitable background by your choice of a lens or aperture setting. For example, in the portrait near right, the surroundings are a vital part of the story, and the choice of a wide-angle 35mm lens shows the foreground and background with equal clarity. But in the scene below, the photographer isolated the potter from a confusing background by using the limited depth of field of a wide aperture (f/4) on a normal lens.

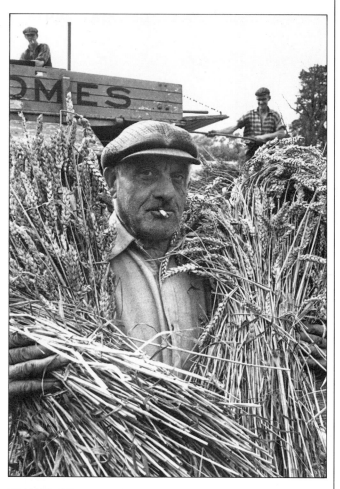

*Armfuls of wheat* frame the face of an English roof thatcher collecting material for his craft. By using a field as the background for the portrait, rather than showing the man on a ladder, actually laying straw on a roof, the photographer avoided a hackneyed image.

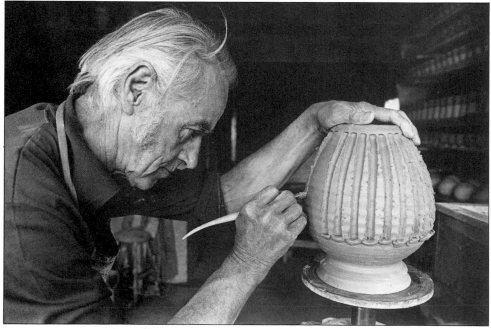

*A potter concentrates* on decorating his work. The soft, even light from a nearby window picks out every detail in the clay of the carefully sculptured pot, and, the finer lines on the craftsman's hands and face.

*A ballerina* sits in front of an etched window that celebrates her art. By using a photoflood lamp to light the glass from behind, and basing the exposure on the brightness of the window, the photographer turned the real dancer's graceful figure into a silhouette.

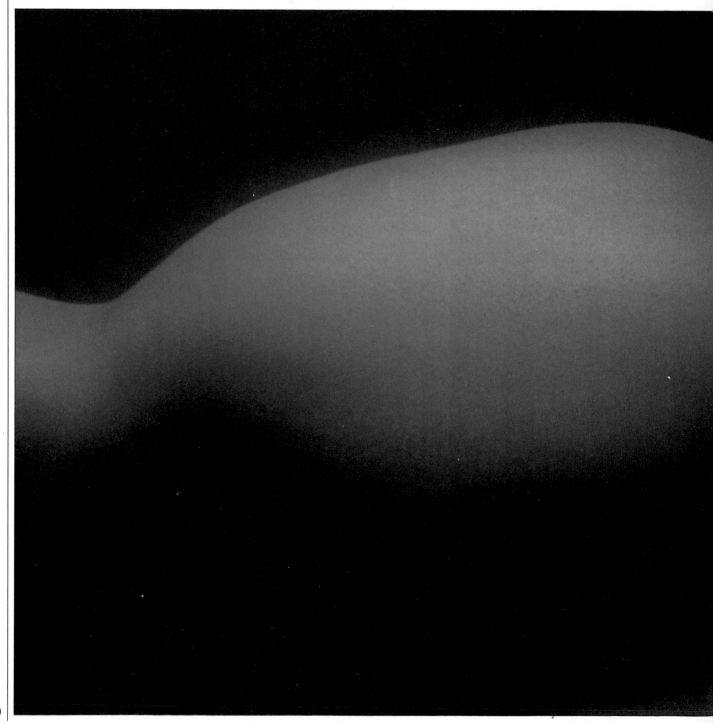

# PHOTOGRAPHING THE NUDE

Photography can make of a naked body pictures ranging from high art to cheesecake vulgarity. Few images have more power to evoke strong feelings. And few subjects need more skill, tact and judgment of what will produce a successful image. The aim of this final section is to look at nude photography as a classic way of studying shape, form, texture and the strength or grace of the human body when in motion and at rest.

If you are exploring this subject for the first time, a good starting point is to form a precise idea of the picture you are going to take and then try to control all the elements toward that end. This does not rule out improvisation; an unexpected lighting effect or a blowing drapery may initiate a wholly different idea. But in nude photography an unplanned approach is likely to produce only a graceless picture. To reveal the visual richness of the human form, and to do so without blatancy, you must exercise the maximum care and selectivity. This is true whether you are showing a full figure or closing in on the kind of elemental form abstracted in the picture opposite. Only by learning to control the pose, the setting and the lighting can you produce photographs that reveal an inherent beauty rather than a clinical truth.

*Like a smooth stone softened by river water, a woman's hip becomes a pure sculptured form in this study. The photographer used diffused toplighting to create subtle gradations of tone that suggest the bone beneath the skin.*

# The simple approach

Nude photography requires mutual confidence between you and your subject. No one – not even the most experienced model – feels completely at ease unclothed before a camera. Dancers, who are used to controlling their bodies and regarding them objectively, often make good subjects, as do gymnasts. But if you live in or near a large city, you might consider hiring a professional model. Even then, much will depend on your ability to make your subject feel at ease.

An indoor setting is best unless you can find a completely secluded garden or beach. Your subject will be more relaxed if assured of this kind of privacy, and indoors you will have more control of lighting and background. In addition, you can set up your equipment well in advance and make sure the room is warm: mottled skin and goose bumps are not conducive to good pictures.

The subject should always wear loose clothing for several hours before a session: underwear elastic or tight waistbands leave marks on skin that do not fade quickly. Conduct the session as a two-way process in which the subject is involved in what you are trying to achieve. You will get better results if you explain why you want a different pose and if you encourage the subject to suggest ideas.

Simple, classical poses are frequently the most effective, certainly for a start. A pose that appeals to your sense of the dramatic will not work if it makes your subject feel physically uncomfortable or embarrassed. Few bodies are perfect, and most people are self-conscious about defects, real or imagined. The two photographs here show how comfortable poses, and the use of lighting to conceal as well as to reveal, can produce images that owe their beauty to simplicity. The pictures also show how black-and-white film, emphasizes light and line, and helps to make the images objective.

One way to accentuate lovely lines, such as the curve of breast and hip opposite, is to use a pose that gently stretches and tautens the body. Here, the model raised her arms to create a graceful, fluid line from elbow to thigh. Partly concealing the face helps to focus attention on the figure, and will help to give a shy subject more confidence. Finally, encourage your model to take deep breaths. This will help to release any tension, and also gives a more flattering line to the stomach and waist.

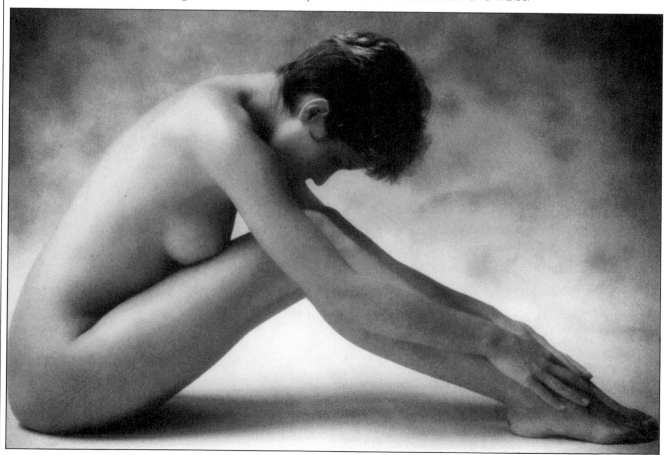

**The rounded purity** of a
female form is outlined by
strong sidelighting from a
window. The woman's pose,
with her arms raised above
her head and with her weight
resting on one side, gives
movement and attractively
lengthens the body's line.

**The natural seated pose**
at left accentuates the clean
supple lines of a youthful
body. To put the subject at
ease, the photographer simply
used light from a flash unit
bounced off the ceiling for
a gentle, flattering effect.

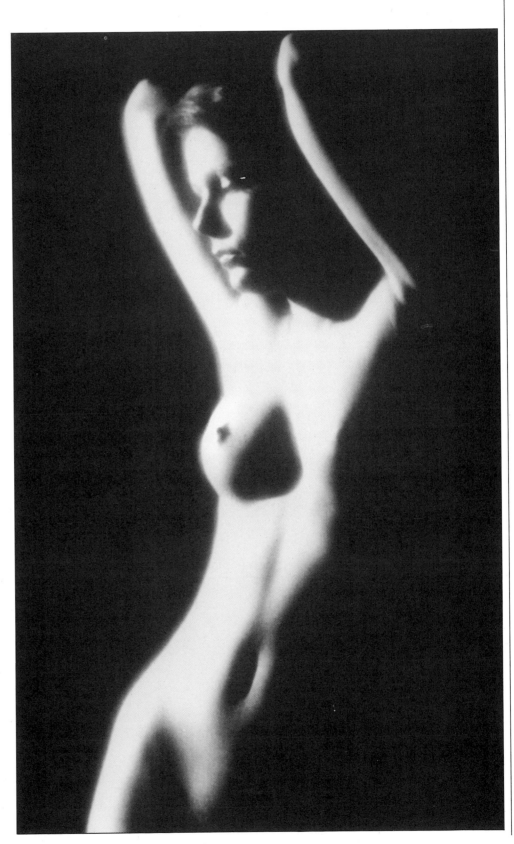

# Human geometry

One approach to nude photography is to consider the body mainly in terms of contours and shapes. Reduced to a series of curving outlines, nudes make strong, graphic images.

To emphasize shape, you need to simplify the figure, using shadow to suppress surface detail and to limit the tonal range that provides modeling and the sense of rounded form. Lighting is the key. A hard light from above and behind the subject will highlight structural outlines and create dense shadows to block in shapes. Strong backlighting will reduce the figure to a silhouette, or make limbs seem almost translucent in a blaze of light, as in the image below. Softer backlighting combined with toplighting, at far right, displays a torso's symmetry and suggests its rounded form.

Try to pose the subject in ways that stress the body's natural lines. An arched back, arms at full stretch or limbs bent at acute angles will all create dramatic shapes that lighting angles can further exaggerate. Sometimes you can use the strange shapes cast by shadows as key elements, prompting a viewer to see familiar outlines in a new way. The undulating shadow of the girl's stretched body in the middle picture is a striking example.

However carefully you pose and light a figure, you can easily ruin the desired effect with a confusing background. Plain backgrounds that provide some tonal or color contrast with the subject are best. If the surroundings include distracting elements, change your viewpoint to omit them. Alternatively, frame the figure so that the background becomes part of a calculated pattern of shapes.

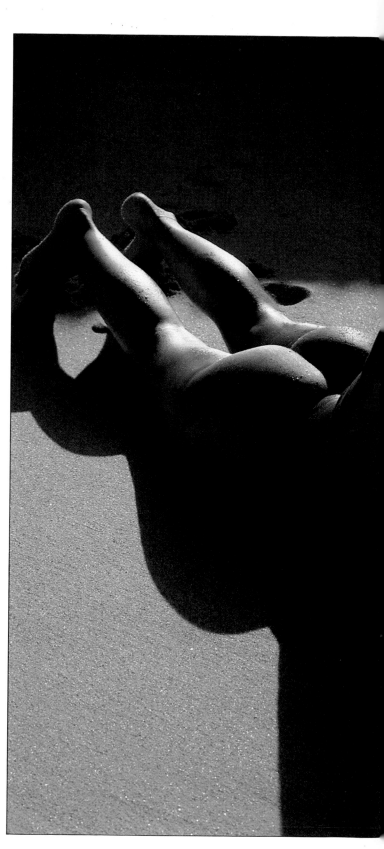

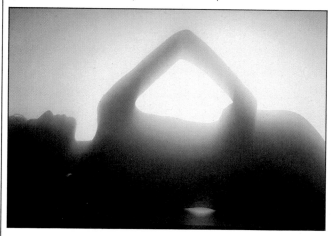

*Intense backlighting from several photoflood lamps gives a refined, translucent quality to the lines of a profiled, reclining woman resting one hand on her hip.*

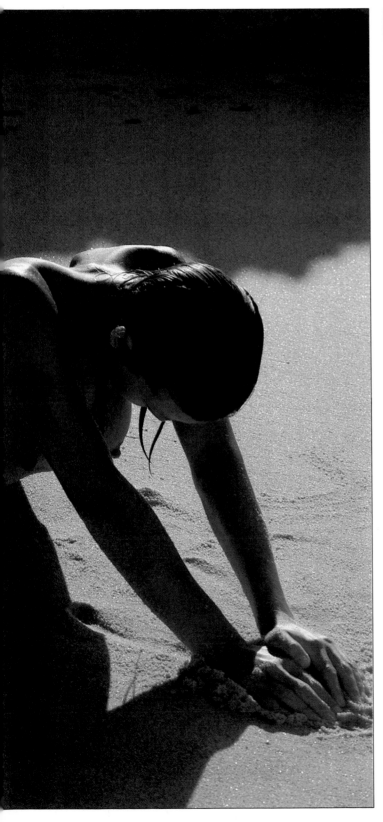

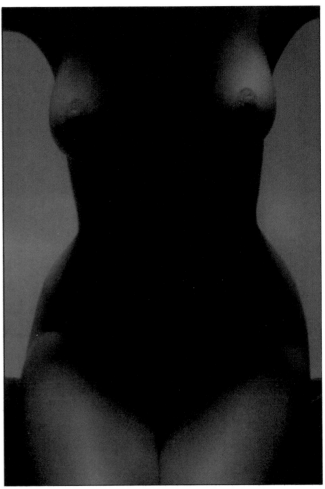

*The generous curves* of
*a seated female nude (above)*
*are framed to display their*
*perfect symmetry. Soft light*
*above and behind the figure*
*emphasizes the fluid outline.*

*The athletic* *tautness of*
*the girl's body at left is*
*accentuated by hard, direct*
*sunlight. A curving shadow*
*on the sand echoes and*
*exaggerates the shapes.*

# Form and figure

The human figure, with its complex, subtle and shifting masses, has always preoccupied sculptors and challenged their basic ability to translate living forms into stone or wood. For photographers, using light and shade to give a realistic impression of a figure in the round has a similar fascination.

Lighting for form must be angled in relation to the camera viewpoint so that it skates across the body to show a deepening of tone as surfaces turn away from the light. The photographer who took the picture below placed a flash unit so that light fell across the woman's left shoulder, then positioned the tripod-mounted camera at an angle to the body, as shown in the diagram. To create a romantic mood, the flash was reflected from an umbrella, with a second reflector at the front of the body. The resulting diffused light is soft and flattering, modeling the forms subtly and refining the body's lines. A harder oblique light will produce a more contrasty effect, showing the structure of bones and muscles in greater relief.

Natural daylight is more difficult to control than is studio lighting, but its broad, even quality often provides the best illumination for modeling a figure. The sequence at near right shows how moving a subject and changing the camera viewpoint can convert a shape into a fully rounded form as the light on the body becomes more oblique. And in the picture opposite, sunlight striking a sunbather produces a strong impression of the girl's rounded limbs and torso curving away into shadow.

1

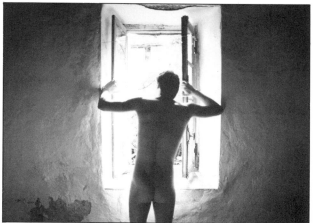

2

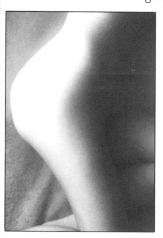

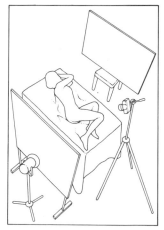

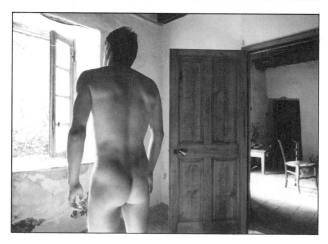

3

*A soft sidelight, as diagrammed at the right, shows the gentle curves of a slender woman. A lamp directed through diffusing material lit her from one side, and a reflector placed opposite lightened the shadows.*

*Near a window (1) the man at top dissolves in an intense, overexposed highlight. Facing the window (2), he appears simply as a dark shape. But farther back (3), sidelight from another window reveals his form.*

*Strong sun and shadows model the body of a girl as she turns to smile at the camera. Sun lotion glistening on her skin intensifies the highlights and adds to the tonal gradations that convey the sense of roundness.*

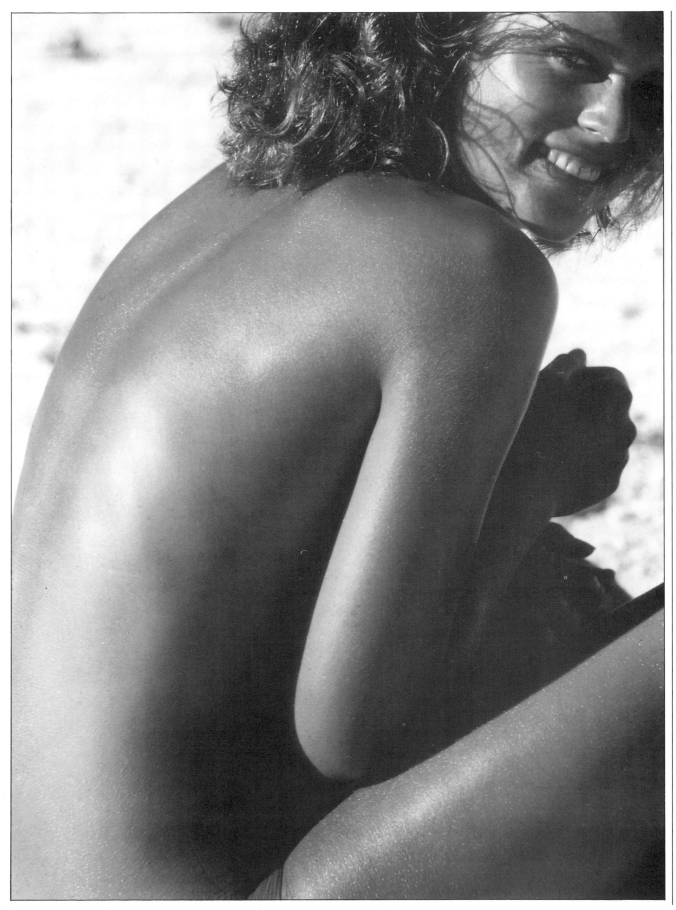

# Texture and the body

Glamor photographs tend to portray bodies as uniformly even and smooth – and therefore unreal. But human skin – the basis of our whole sense of touch – has textural qualities, and photographs that use light to explore these qualities communicate strongly because they add a new, tactile dimension that moves the image closer to real life.

To show skin texture in sharp detail, strong side-lighting is best. Indoors, the simplest approach is to position the subject so that natural light from a window falls on one side. Alternatively, angle a tungsten photolamp to cast an oblique light on the figure. Often you can reveal interesting textural contrasts by closing in on a selected part of the body. For example, in the picture below, the fuzzy texture of a man's leg and forearm contrasts with the smoothness of his shoulder and torso.

Another way to emphasize texture is to oil or wet the body so that the surface reflects light. Oil has a dramatic, sculptural effect; for this reason, it is more suitable for abstract images. But water gives a delightfully fresh, natural look. And cold water has an invigorating effect, tautening the skin and making it glow alive.

A plain dark background, as in the two pictures on this page, will throw textures into relief. On the other hand, textured surroundings can accentuate the softness and delicacy of skin and hair. You could experiment with thick toweling or a gauzy material indoors. And outdoors the natural textures of sand, wood or rocks, as in the picture opposite, all provide effective contrasts.

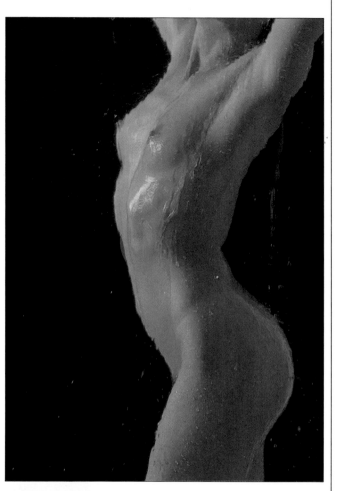

*A play of water* gives movement and light to the supple body above. Gleaming highlights on the ribs contrast with the rounded, shadowed areas of the thigh and hip. Droplets of water accentuate the slightly granular texture of the skin. The model stood under a shower for a picture taken with flash to freeze the drops.

*Strong, oblique light* picks out the downy hairs covering a man's arm and leg. Softer light on the rest of the body heightens the contrast between smooth, hairless areas and the coarser texture of the skin on the prominent knee and elbow.

*A crouching figure* within a secluded bowl of rock seems to fit naturally into her surroundings. Rounded contours of weathered sandstone echo the subject's soft curves and set up a subtle contrast between rough and smooth surfaces.

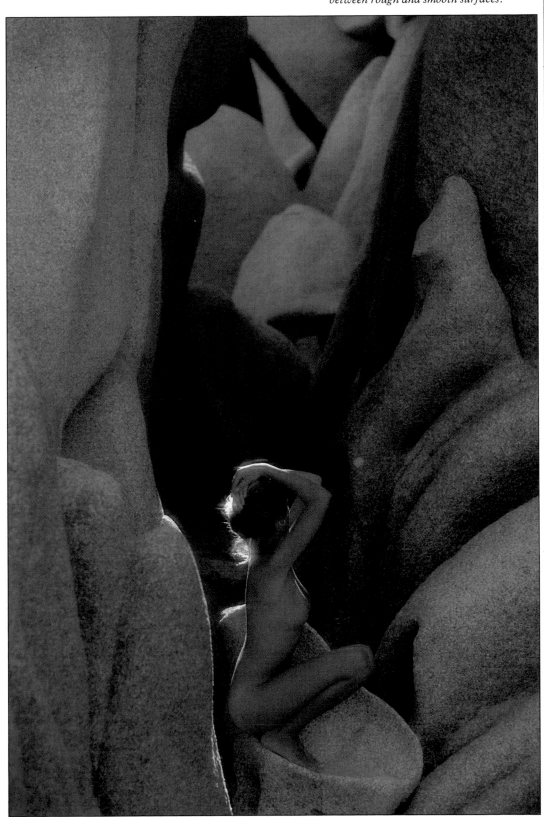

# The minimal approach

Some of the most expressive studies of nudes show only a small part of the body. One practical advantage of this is that you can avoid a subject's weaker features and concentrate instead on his or her strongest attribute – perhaps the beautiful line of a back or the shape of a muscular leg. More positively, you can focus on detail to create arresting semi-abstract images. A picture that includes the whole body inevitably lessens the impact of individual parts, and also involves the viewer in a subjective way with the model. Cropping the head out of the frame immediately focuses attention on the contours, shapes or forms of the body and limbs and makes us consider their objective qualities.

Considered in this anonymous way, sections of the body make compelling compositional features. For example, the pictures on these two pages all take what may be called a minimal approach to the nude – using parts of the body as relatively small areas in the picture frame. Because sections of the body, even when isolated in this way, still retain human connotations, such images often have a surprising power, as in the picture below.

Sometimes outdoor settings enable you to frame the subject so that a detail of the body appears to become part of the surroundings. At near right there are similarities in tone, texture and form between the midriff and the indented sand. And the boulderlike shape in the foreground of the seascape opposite is only just recognizable as the nape of a neck and a curved back.

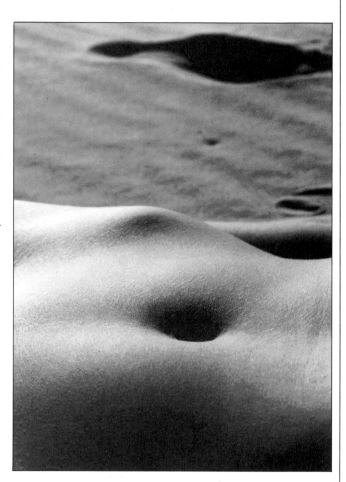

*The navel* in a tanned, taut stomach (above) echoes the pattern of an oval dip in the sand. Sharp focusing on the body, while allowing the background to blur, has made the different textures appear remarkably similar.

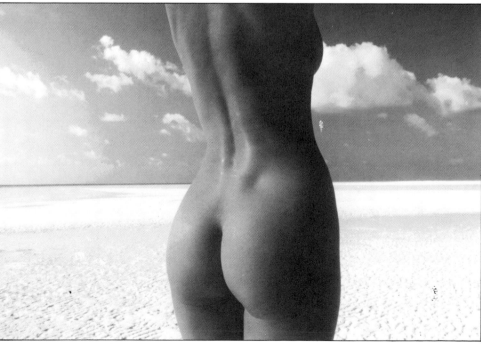

*An upright torso* (left) etched against a spacious beach and sky establishes a commanding stillness. Bold framing, with the legs and arms cropped out, suggests solidity and permanence, a more-than-human presence.

*The smooth curve* (below) lined up precisely with the edge of the sea, puzzles the eye. To make this striking composition, the subject bent her neck beneath the lens.

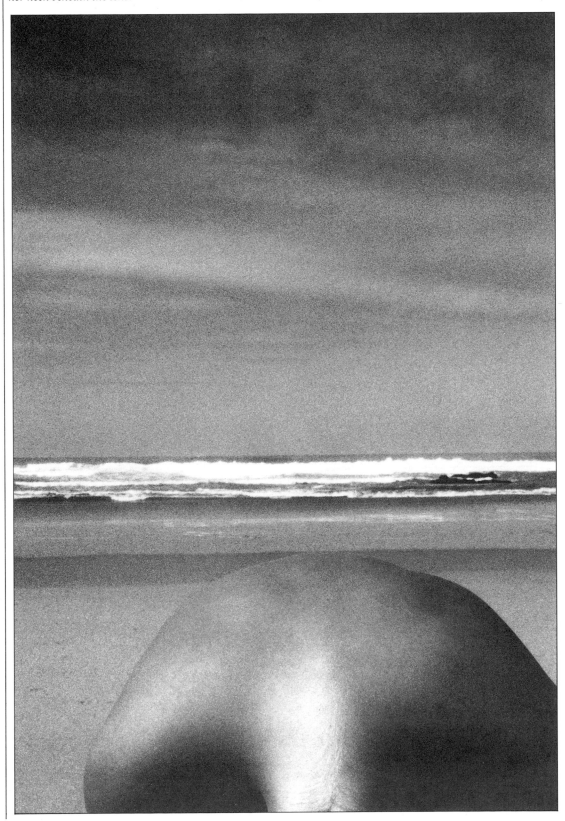

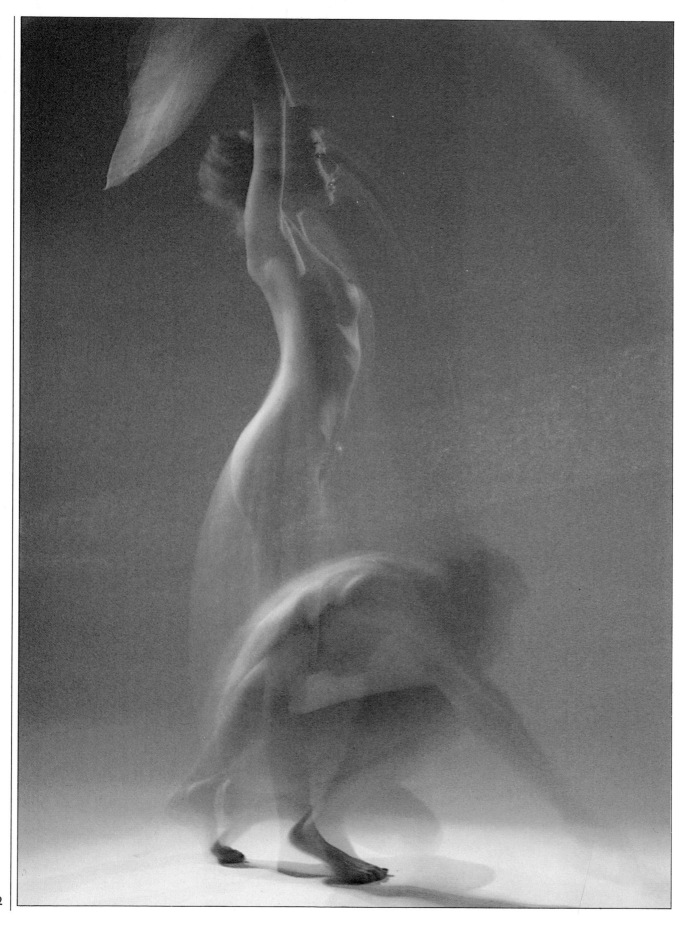

# Figures in motion

Images of nudes are usually static, carefully arranged compositions, but a photograph of a figure in motion can reveal the grace and energy of the body.

The camera's shutter chiefly controls the way a moving figure appears on film. Using a very slow shutter speed, of 1/4 or even a full second, you can record two quite different poses in a single picture, as in the image at left. A swift movement from one stance to the next will appear as a ghostly, streaked shape. To make the most of the flowing lines this creates, set the camera on a tripod facing a dark background, or take the picture outdoors at night. Use hard light so that the movement of the illuminated figure will leave clearly defined lines across the plain background.

A shutter speed in the range of 1/8 to 1/30 will produce a less dramatically abstracted image, such as that at bottom right. These moderately slow speeds, which require camera support, can slightly blur the contours of the body, to give an impression of swirling, balletic grace – often flattering the shape of a less-than-perfect model.

A shutter speed fast enough to freeze all movement – as used for the picture at left below – will still reveal aspects of the nude form that are different from those of a static figure. Apart from the obvious difference in pose, photographing a nude at shutter speeds of 1/500 or 1/1000 can show the subtle changes in muscle tone and tension created by vigorous exercise.

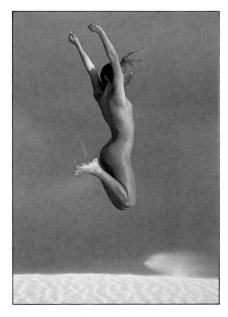

*Frozen in midair* (above) by a fast shutter speed of 1/1000, a leaping figure defies gravity. The girl's arched back and tightly folded knees give the image tension, and the flick of sand at her feet adds to the sense of movement.

*In one flowing movement* (left), a dancer springs to her feet. An exposure of one second enabled the photographer to record the woman's movement from low crouch to upright stance, and to trace the course of the silk scarf in her hand.

*The dancer's pose* (right) is an instant of equilibrium in a series of flowing turns. A shutter speed of 1/8 produced a clear image of her poised body but allowed motion to blur her head and limbs.

# Indoor nudes

A private, indoor space has obvious advantages in nude photography. As well as being secluded and warm, an interior is easy to control and adapt to suit your photographic needs. However, the mood and meaning of a nude study in a home environment may be significantly different from that of an ordinary portrait in the same surroundings. And because the use of furnishings and everyday objects immediately introduces a subjective, personal note, you need to be especially aware of what meaning the picture will convey. Otherwise you may produce a photograph that is unintentionally voyeuristic.

At the same time, the essential simplicity of a nude body may be muddled by a cluttered setting. The way to avoid this is to choose the simplest possible location. Avoid using a room that has strongly patterned carpet or wallpaper, and keep any furniture to a minimum. For the graceful picture on the opposite page, the photographer introduced only a few carefully chosen touches to establish the atmosphere of luxury. And in the photograph at near right, a bathroom provided a realistic and natural setting for a classically simple nude study. You might consider using the spartan interior of a bare studio – or of a newly decorated room – to make nude studies of similar striking simplicity.

If your aim is to show the body naturally rather than to dramatize aspects of shape, the light from a large window is ideal. With strong light flooding directly through the windows, you will need to base exposure on the dark side of the body to lighten the shadows, or else use diffusing material such as tracing paper stretched over the window, as for the picture opposite. When the light is indirect, as in the picture at near right, white or pale walls reflect enough light into the shadows to produce a detailed and balanced result.

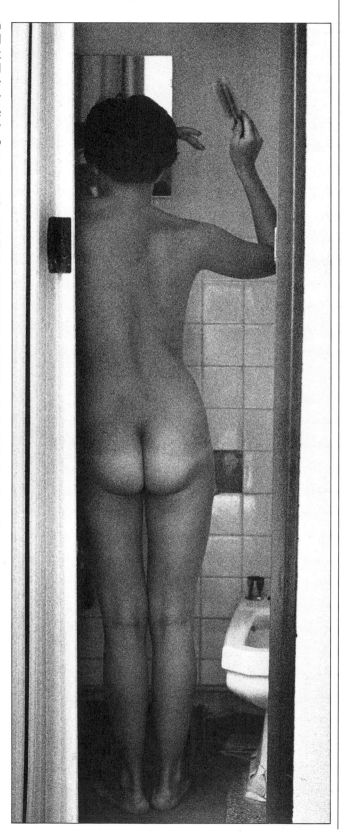

*A bathroom doorway (right) effectively frames and emphasizes the long lines of a girl's body as she completes her morning toilette.*

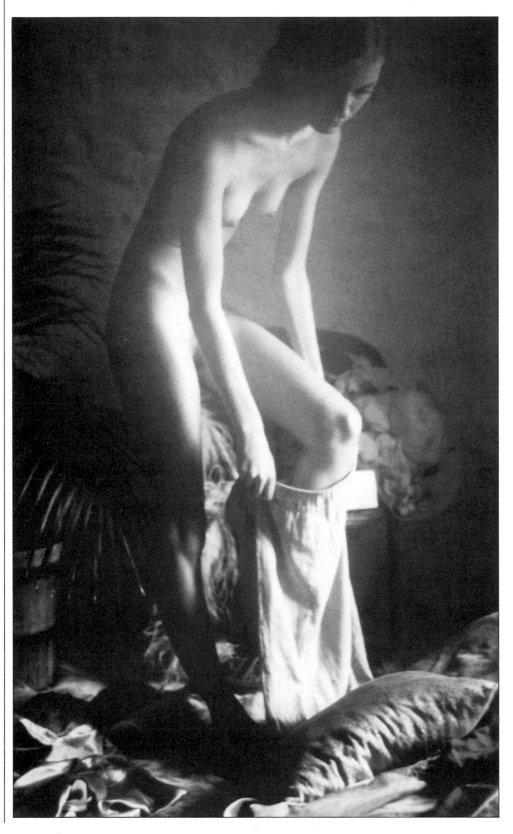

*The delicate languor* of
the picture at left typifies
the work of David Hamilton,
a master of such youthful
nudes. For the romantic
atmosphere, he used only a
plant, a chair and a few
cushions and fabrics, adding
a soft-focus filter to further
soften the light.

# Nudes in landscapes

In outdoor settings, nude figures can seem to blend in as natural forms in natural surroundings. A landscape context can have many different meanings depending largely on the viewpoint. For example, in the picture at left below, the photographer has suggested a harmonious relationship between the woman and the earth by placing her in the foreground to emphasize similarities of scale and shape with the rocks she embraces. Conversely, a small, distant figure overwhelmed by a stormy landscape might have suggested helplessness.

The ability of landscape elements to give nudes a poetic power appears even in a picture such as that at right below, in which the loneliness of an abandoned house is conveyed simply by the foreground weeds and the reflection of a hillside and sky in the right-hand window. The large picture opposite links nature and humankind more deliberately by using the side of a shadowed tree to suggest that the figure is half-flesh, half-bark.

Finding a private outdoor location is not easy; it is usually a good idea to look for one in advance and then return with your model and equipment. Even at popular places, you can often work uninterrupted just after dawn on a summer morning, when the soft, oblique light is also ideal for showing form. Take blankets or a warm cape so that your model can keep warm during and after a photo session.

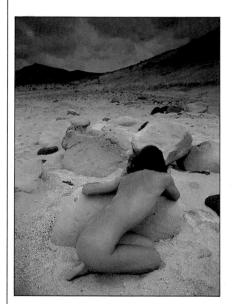

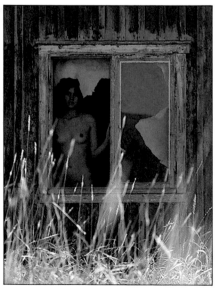

**Crouched on the sand,** *this woman seems to draw warmth from the rocks. A graduated filter over the lens made the distant landscape dark and stormlike, but left the foreground unchanged.*

**Tall weeds,** *and torn paper pasted over the windows of a derelict house set up the eerie mood of this picture. A few visual clues – the reflected sky and hillside – establish the location.*

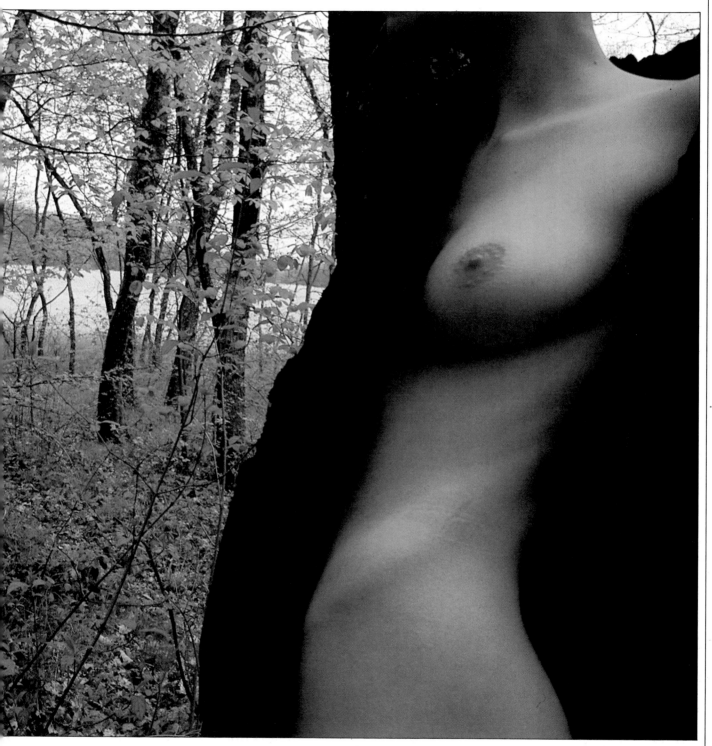

**Merging with a tree,** *a body half-hidden in shadow seems smooth on one side, gnarled on the other. The light and dark bands echo the vertical lines of the surrounding woodland.*

# Props and accessories with nudes

A judicious choice of props will enliven and extend the range of your nude photographs whether you are taking pictures indoors or outdoors. Props can help to create a particular context for the subject, as in the photograph of a sun worshipper below, in which the carefully positioned chair, book and headscarf produce a natural, well-balanced composition. Alternatively, you may use props such as clothing, jewelry or fabric to complement or contrast with a nude figure in tone, color or texture. In the photograph at far right, the delicacy of the lingerie conveys a sense of lightness to the image.

Including such personal touches as the small pendant worn by the girl below will inevitably lessen the anonymity of a nude study. But props can be equally effective in concealing a body intriguingly or protecting it from a too-blatant display of nudity. In the small photograph at right, the parted curtains frame the subject, emphasizing the grace and shape of the body's profile while giving movement and textural contrast to the image.

As these pictures show, props need not be elaborate: a single, well thought-out detail can lift an image out of the ordinary into the memorable. But do bear in mind that any prop used must complement and not dominate the image. If a very pale or dark prop forms a large element in the picture, you will probably need to take a key reading from the body to make sure that you accurately record the all-important skin tones.

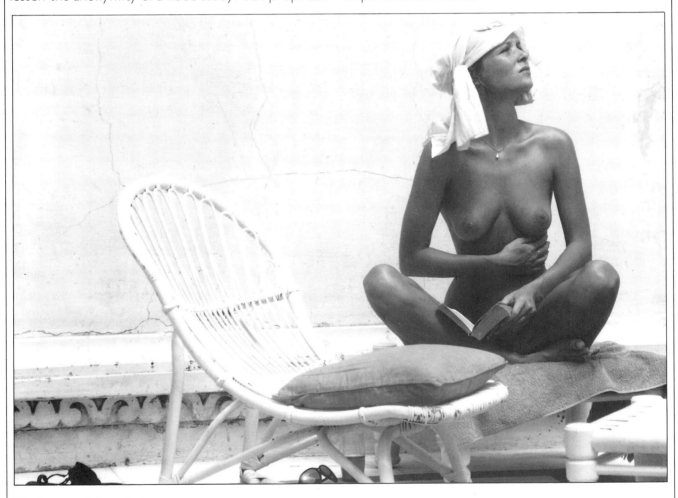

*The harmonizing shapes* and tones of some carefully chosen props are a perfect foil for the strongly posed tanned body above. Although the symmetry was contrived, the effect is very natural.

*A string curtain* accentuates
the streamlined curves of a
slender figure. The neutral lines
of the curtain also enabled the
photographer to average the
exposure over the whole scene
in spite of a dark background.

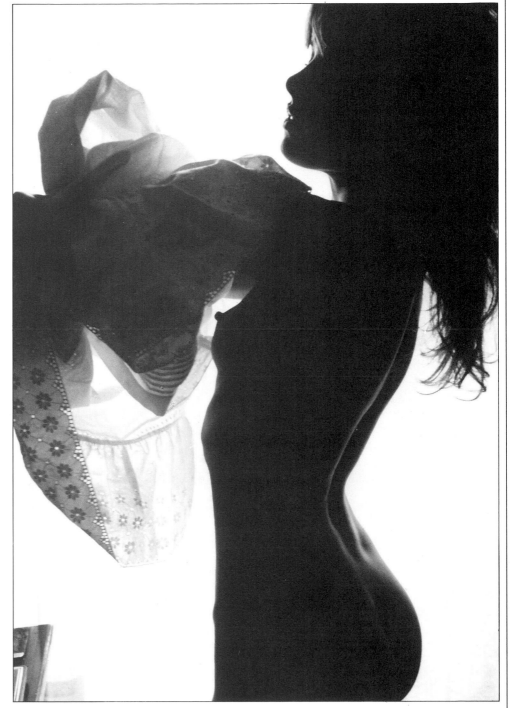

*The frilly petticoat* needed
backlighting to emphasize its
delicacy. The photographer
posed the girl against a fine
net curtain, and chose an
exposure midway between the
background and the skin tones.

# Changing the image

You can make fascinating pictures by using the human body as a strong motif for experiments in changing the image. The shape of the nude figure is so unmistakable that even after dramatic distortions of color and form, it still retains its identity.

Of all reflective surfaces, water is the most useful and versatile for nude photography, because you can vary the accuracy with which it reflects the body's shape back to the camera. In a perfectly still pool, the mirror-like surface may form a symmetrical picture that duplicates the shape of the nude. But even a slight ripple will distort the reflection – as shown in the picture below.

A figure beneath the water will appear more strongly distorted. And if the surface is agitated, the result may be a strangely fragmented abstract image, such as the one at right. Here, reflections on the water and decorative tiles on the bottom of the pool combine with the shape of the underwater swimmer to make an intricate pattern.

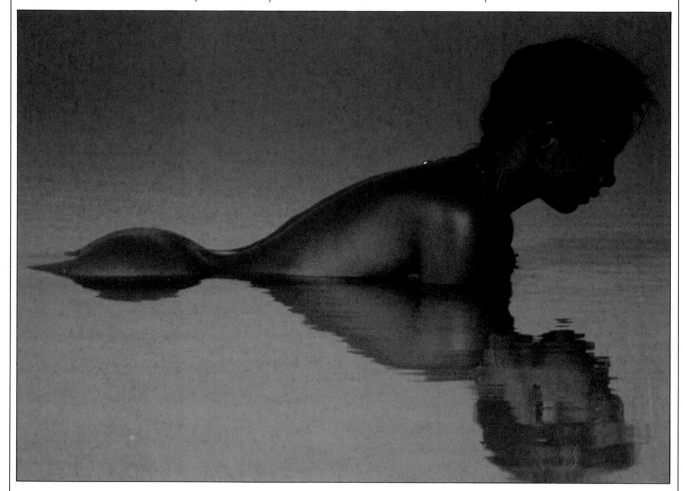

*In a blue pool,* a young woman gazes at her own reflection. By kneeling down and holding the camera just inches above the surface of the water, the photographer made the image almost perfectly symmetrical.

**Under the rippled water**
*of a swimming pool, a female
body's distorted shape forms
part of an abstract image.
The use of black-and-white
film simplified the complex
pattern made by the figure
and the mosaic tiles below.*

# Glossary

**Aperture**
The opening in a lens that admits light. Except in very simple cameras, the size of the aperture can be varied to regulate the amount of light passing through the lens to the film.

**Backlighting**
A form of lighting in which the principal light source shines toward the camera and lights the subject from behind.

**Bracketing**
A way to ensure accurate exposure by taking several pictures of the same subject at exposure settings slightly above and below (that is, bracketing) the presumed correct setting.

**Cable release**
A thin cable encased in a flexible plastic or metal tube, used to release the shutter when the camera is not being handheld.

**Depth of field**
The zone of acceptable sharp focus in a photograph, extending in front of and behind the part of the subject that is most precisely focused by the lens. Depth of field is greater with the lens set to a small aperture. Many SLRs have a preview control that allows the depth of field to be checked before the shutter is released.

**Diffused light**
Light that has lost some of its intensity by being reflected or by passing through a translucent material. Diffusion softens light, eliminating both glare and harsh shadows, and thus can be of great value in photography, notably in portraiture.

**Double exposure**
The recording of two images on the same frame of film. When more than two images are recorded, the term "multiple exposure" is used.

**Exposure**
The total amount of light allowed to pass through a lens to the film, as controlled by both aperture size and shutter speed. The exposure selected must be tailored to the film's sensitivity to light, indicated by the film speed rating.

**Fall-off**
Reduction in the intensity of light as distance from the light source increases.

**Fill-in light**
Additional lighting used to supplement the principal light source and brighten shadows. For example, fill-in light may be supplied by redirecting light with a cardboard reflector or by using a flash unit.

**Filter**
A thin sheet of glass, plastic or gelatin placed in front of the camera's lens to change the appearance of the picture.

**Flash**
A very brief but intense burst of artificial light, used in photography as a supplement or alternative to any existing light in a scene. Batteries supply the power to most electronic flash units. Some small cameras have a built-in flash, but for most handheld cameras, independent flash units fit into a slot on top of the camera, or can be detached from the camera with the use of a linking cable.

**Flash exposure meter**
An exposure meter that is designed to read only the light from flash sources, ignoring all other types of light. The photographer holds the meter close to the subject and points it at the flash, which when fired causes a needle to swing across a scale or one of a series of diodes to light up on the meter. This indicates the correct aperture to set on the camera.

**Key**
A term describing the prevailing tone of a photograph. "High key" refers to a predominantly light image; "low key" refers to a predominantly dark one.

**Lens**
An optical device made of glass or other transparent material that forms images by bending and focusing rays of light. A normal lens produces an image that is close to the way the eye sees the world in terms of scale, angle of view and perspective. For most SLRs, the normal lens has a focal length of about 50mm. A wide-angle lens (for example, 28mm) takes in a broader view of a scene than does a normal lens, and a telephoto lens (for example, 135mm) shows a smaller area on a larger scale. A zoom lens is continuously variable in focal length. For example, with an 80mm–200mm zoom lens, you can choose any focal length between the lower limit of 80mm and the upper limit of 200mm, and reduce or enlarge the scale of an image without throwing it out of focus.

**Multiple exposure** see DOUBLE EXPOSURE

**Normal lens** see LENS

**Photolamp**
A tungsten light bulb specially designed for photographic use. It is similar to a household bulb, but bigger and brighter.

**Preview control** see DEPTH OF FIELD

**Reflector**
Any surface capable of reflecting light, but in photography generally understood to mean sheets of white or silvered material used to reflect light into shadow areas. A popular type for use in controlled situations is the umbrella reflector – shaped like an umbrella but usually colored gold, silver or white.

**Rimlighting**
Lighting in which the subject appears outlined against a dark background. Usually the light source is above and behind the subject, but rimlit photographs can look quite different from conventional backlit images, in which the background is usually bright.

**Self-timer**
A device found on many cameras that delays the operation of the shutter, usually until about eight to ten seconds after the release is pressed. This allows the photographer to set up the camera and then pose in front of the lens.

**Sidelighting**
A form of lighting in which light falls on the subject from one side. Sidelighting produces some dramatic effects, casting long shadows and emphasizing texture and form.

**Snoot**
A cone-shaped attachment that fits over a photographic lamp to concentrate the light over a small area. Snoots are usually metal, but can be improvised from stiff black paper.

**Soft focus**
Deliberately diffused or blurred definition of an image, often used to create a dreamy, romantic look in portraiture. Soft-focus effects are usually created with special lenses or filters.

**Spotlight**
A photographic lamp that produces a concentrated beam of light.

**Stopping down**
A colloquial term for reducing the size of the lens aperture.

**Telephoto lens** see LENS

**Tungsten light**
A common type of electric light for both household and photographic purposes, named after the filament of the metal tungsten through which the current passes. Tungsten light is much warmer in color (more orange) than daylight or electronic flash, and with daylight-balanced slide film you must use a blue filter to reproduce colors accurately. Alternatively, you can use a special tungsten-balanced slide film.

**Wide-angle lens** see LENS

**Zoom lens** see LENS

# Index

# Acknowledgments

**Picture Credits**

Abbreviations used are: t top; c center; b bottom; l left; r right.
Other abbreviations: Ex for Explorer, JG for John Garrett, IB for Image Bank, Magnum for The John Hillelson Agency and SGA for Susan Griggs Agency.

**Cover** Ian Miles/Image Bank

**Title** Robin Laurance. **7** Hideki Fuji/IB. **8** Al Satterwhite/IB. **9** Dick Scott-Stewart. **10** Joseph Brignolo/IB. **11** Adam Woolfitt/SGA. **12-13** David Hamilton/IB. **14** Paulo Curto/IB. **15** Pete Turner/IB. **16-17** JG. **18** bl Patrick Ward, r Julian Calder and JG. **19** tl Th. Rouchon/Ex, tr JG, b Nancy Brown/IB. **20** bl br JG. **20-21** Graham Harrison/Daily Telegraph Colour Library. **21** t Ted Streshinsky/IB, bl br JG. **22-23** Mayotte Magnus. **24-25** Mayotte Magnus. **26** Graeme Harris. **27** t JG, b Mayotte Magnus. **28** t Gene Lincoln/Tony Stone Associates, b Clive Barda. **29** Patrice Duchemin/Ex. **30** l David Hamilton/IB, r John Miller. **31** t Robin Laurance, b Tino Tidaldi. **32** t Julian Calder, b David Whyte. **33** t Clive Barda, b David Whyte. **34** John Sims. **35** tl bl Frank Herrmann, r John Miller. **36** JG. **37** tl Victor Yuam, r Brian Seed/Click/Chicago. **38** Michael Busselle. **39** l Michael Busselle, tr John Sims, br Linda Burgess. **40** l Ian Miles/IB, r I. Thoma/IB. **41** Th. Rouchon/Ex. **42** Nancy Brown/IB. **43** t Patrick Ward, bl Anne Conway, br John Hedgecoe. **44** t Julian Calder, b Robin Laurance. **45** Robert Gelberg/IB. **46-47** Dimagio/Kalish/IB. **48** l John Marmaras/Woodfin Camp Associates, r Michael Freeman. **49** tl John Hedgecoe, bl Ph. Ledru/Sygma, r Graham Harrison/Daily Telegraph Colour Library. **50** JG. **51** JG. **52** t Horst Munzig/SGA, b Constantine Manos/Magnum. **53** Bruce Davidson/Magnum. **54** John Cocking. **55** John Cocking, **56** l r Patrick Rouchon/Ex. **57** William Klein/IB. **58** l Steve Benbow/Network, r John Hedgecoe. **59** t John Sims, b Frank Herrmann. **60** all Julian Calder. **61** t Brian Seed/Click/Chicago, b Robin Laurance. **62** Robin Laurance. **63** tl tc tr Per Eide, bl Nick Carter, br Graham Finlayson. **64** Robin Laurance, b Linda Burgess. **65** t Jerry Young, b Richard Haughton. **66** t David Gallant, b David Whyte. **67** t Eve Arnold/Magnum, b Graham Finlayson. **68** Graeme Harris. **69** tl Larry Dale Gordon/IB, tr Julian Calder, b Per Eide. **70** l Helene Rogers, r Burt Glinn/Magnum. **71** Jane Brown. **72** t Anne Conway, b Julian Calder. **73** t Julian Calder, b Michael Freeman. **74** Cecil Jospé. **75** tl Robin Laurance, tr Michael Boys/SGA, b Robin Laurance. **76** tl J. Arthus-Bertrand/Ex, tr Patrick Rouchon/Ex, b Sally Fear. **77** Brian Seed/Click/Chicago. **78** t Frank Herrmann, b Brian Shuel. **79** Burt Glinn/Magnum. **80-81** JG. **82** JG. **83** JG. **84** Michael Boys/SGA. **84-85** Michael Busselle. **85** JG. **86** bl David Hamilton/IB, tc bl Trevor Wood. **87** Ph. Rouchon/Ex. **88** t Larry Dale Gordon/IB, b Michael Busselle. **89** Larry Dale Gordon/IB. **90** t Ph Roy/Ex, b Chris Thomson/IB. **91** Josef Neumann. **92** Michael Boys/SGA. **93** l J. Dommnich/Tony Stone Associates, r Larry Dale Gordon/IB. **94** Richard Dudley-Smith. **95** David Hamilton/IB. **96** l Chris Thomson/IB, r John Hedgecoe. **96-97** Gerard Petremand. **98** James Baes/Ex. **99** l Guy Leygnac/IB, r James Baes/Ex. **100** Paulo Curto/IB. **101** John Hedgecoe.

**Artist** Andrew Popkiewitcz

**Retouching** Roy Flooks

Time-Life Books Inc. offers a wide range of fine recordings, including a *Big Bands* series. For subscription information, call 1-800-621-7026, or write TIME-LIFE MUSIC, Time & Life Building, Chicago, Illinois 60611.

Notice: all readers should note that any production process mentioned in this publication, particularly involving chemicals and chemical processes, should be carried out strictly in accordance to the manufacturer's instructions.

Printed in U.S.A.